JOHN VIRTUE
LONDON PAINTINGS

JOHN VIRTUE
LONDON PAINTINGS

Introduction by Charles Saumarez Smith

Essays by Simon Schama,
Paul Moorhouse and Colin Wiggins

NATIONAL GALLERY COMPANY, LONDON
DISTRIBUTED BY YALE UNIVERSITY PRESS

Publication generously sponsored by
Hiscox plc and the University of Plymouth

Published to accompany the exhibition:
John Virtue: London Paintings
at the National Gallery, London
from 9 March to 5 June 2005 sponsored by Hiscox plc

Associated exhibitions of John Virtue's work:

John Virtue: London Drawings
at the Courtauld Institute of Art Gallery, London
from 9 March to 5 June 2005

John Virtue: London Works
at the Yale Center for British Art, New Haven
from 2 February to 23 April 2006

First published in Great Britain in 2005
by National Gallery Company Limited
St Vincent House
30 Orange Street
London WC2H 7HH

ISBN 1 85709 385 2
525474

British Library Cataloguing-in-Publication Data
A catalogue record is available from the British Library
Library of Congress Catalog Card Number 2004111950

Publisher: Kate Bell
Design: Peter B. Willberg
Production: Peter B. Willberg, Jane Hyne, Penny Le Tissier
Editorial Assistance: Tom Windross
Picture Research: Kim Klehmet
Printed and bound in Italy by EBS

All measurements give height before width
Jacket: **Landscape No. 704** (detail), 2004

CONTENTS

SPONSOR'S FOREWORD

It is a huge pleasure to be able to help the National Gallery display the work of their inspirational choice of Associate Artist, John Virtue.

I have followed John's progress from the banks of the Exe Estuary to Trafalgar Square. I am in awe of his guts and gusto in tackling the grimy cityscape of London after the gentle landscape of Devon, with the challenge of this major exhibition of the resulting work. To me the result is a triumph, but I suspect that as a devotee I am not rational in my analysis, so I nervously await your verdict.

Robert Hiscox

DIRECTOR'S FOREWORD

I would like to thank Robert Hiscox and Hiscox plc for their most generous support of both the exhibition and the catalogue, and Roland Levinsky, Vice-Chancellor of the University of Plymouth, for the additional funding they have provided for the catalogue. Simon Schama, Paul Moorhouse and Colin Wiggins have written intense and stimulating essays, each very different from each other. Amy Meyers, Director of the Yale Center for British Art, and her colleagues, and Deborah Swallow, Director of the Courtauld Galleries, and her colleagues, have all been constant in their support and enthusiasm.

There are many, both from within the National Gallery and beyond, who have contributed to the success of John Virtue's involvement with the National Gallery, but I want, above all, to thank John himself for his extraordinary commitment to this exhibition from the day that he first arrived in the Gallery.

Charles Saumarez Smith
Director of the National Gallery, London

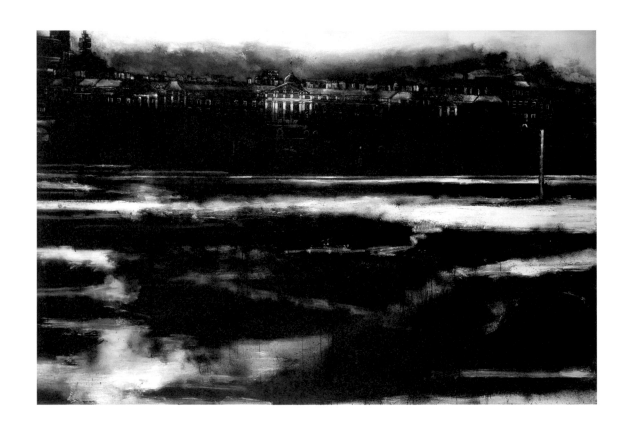

Landscape No. 760
2004, black ink, shellac and acrylic on canvas, 244 × 366 cm
Private collection, Sydney

INTRODUCTION

Charles Saumarez Smith

John Virtue arrived as the National Gallery's Associate Artist on 17 December 2002 and began painting on 6 January 2003. Ever since he arrived, I have felt a sense of sympathy for Virtue as a fellow exile from the outside world, lost in the long, clinical corridors of the undercarriage of the National Gallery, beyond several closed doors and the old road which led out through the east door of William Wilkins's 1838 building to the workhouse beyond.

When I have been feeling particularly gloomy, I have liked banging on his door. Nearly always, the door has opened and there he has been, larger than life, having done more work for his exhibition both at the National Gallery and at Somerset House: in particular, on his eight huge and heroic cityscapes which show the darker moods of the Thames, depicted from the roof of Somerset House, with a view south and east out towards Tower Bridge and the old Bankside power station (now Tate Modern), and the distinctive dome of St Paul's, still clear on the skyline, and the Gherkin, becoming more prominent every week.

I could not believe – and have found infinitely rewarding – the feeling of volcanic eruption which went on beyond those locked doors, as if, trapped in an institution dedicated only to Old Master painting, Virtue has been determined to show its continuing vitality, painting every day in dialogue with his heroes from the past: in particular, Constable and Turner, black-and-white photographs of whose works he keeps on the walls of his studio.

One day, I asked Virtue if he had been up on the roof of the National Gallery. There, just beside the dome which housed the drawing studio of the nineteenth-century Royal Academy, it is possible to look out over Trafalgar Square. The people on the Square are like matchsticks, but the buildings are, by contrast, emblems of the old Empire – South Africa House and Canada House and Admiralty Arch. Not long afterwards, I discovered that he had temporarily forsaken his morning patches on the roof of Somerset House and the South Bank of the Thames and was now leaning against the dome of the National Gallery drawing the view south: the curious mixture of serenity and swirl as one looks out from the rooftops over the early morning city, Nelson's Column defining the composition.

What exactly is the appeal of Virtue's art? I think that it partly lies in the fact that, for the past two decades, contemporary art has been so preoccupied with subject matter and not with the experiential effect of drawing. Virtue's attitude to the task of depiction is extremely direct. He produces a *gestalt* view of the city through the fluency of grand, gestural drawing straight onto the canvas, based on a multitude of drawings done *in situ*. He provides on canvas a very distinctive view of the world which is quite obviously an ostensibly unmediated product of his highly original and potent visual imagination. He transforms what he sees into drawings which are full of visceral movement.

We have become unused to artists making use of these characteristics of drawing and painting – even in spite of the fact that such a style of expressive drawing evidently has its roots in the action painting of the 1950s, in Jackson Pollock, for example, whose work between 1947 and 1950 Virtue greatly admires. I know that Gombrich was a big influence in the Slade in the mid-1960s, where he used to lecture and where *Art and Illusion*, published in 1960, was one of the key texts. And there is something of the earnestness of the relationship between subject and expression in Virtue's art which reminds me of Gombrich. He certainly continues to refer to Gombrich's *Story of Art* and remains intrigued by the issues of representation described in *Art and Illusion*.

A second issue, which perhaps helps to account for the appeal of Virtue's recent art, is how he depicts the city. For most of his life, he has painted the countryside in the English landscape tradition, following Gainsborough, Constable and Turner. Now, suddenly, after a lifetime spent in Lancashire and Devon, he has had to confront London – 'the great wen', as it was known to the Victorians. In his paintings, he conveys both the fear and the excitement of the megalopolis – with an extraordinary, swirling, obsessive, imaginative sweep. There are, of course, recent writers who have tried to express what the detailed topography of London means to them, including Peter Ackroyd, Patrick Wright and Iain Sinclair, but John Virtue's London is depopulated. His version of the city is not concerned with its history, nor its folk memory, nor its mythology, but, instead, he provides an intense visualisation of the remembered experience of particular buildings, of their visual relationship to one

another, of the overall topography of the city and, above all, how it moves: in other words, what he describes as its abstract, visual pattern.

The expressive power and symbolic effectiveness and authority of Virtue's recent work is quite obviously authentic, the product of long labour and looking at the landscape in the hills and moorland of his native north-east Lancashire, the edge of Dartmoor and the Exe Estuary, and now in the very different setting of London. It is big art, deeply imaginative in its sense of scale and ambition, and, in particular, in the way that it demonstrates the atmospheric qualities of light and shape and river.

JOHN VIRTUE: THE EPIC OF PAINT
Simon Schama

There's something missing from John Virtue's skylines: the London Eye. And that's not just because he dislikes the featherlight airiness of the wheel, so at odds with his bituminous, Dante-like vision of a beaten-up, endlessly remade city of men scarred by the damage of history. Virtue's London is more battlefield than playground; his angle of vision the angel's hover rather than the child's expectation of ascent. But his aversion also stems from what the Eye represents: bubble-glazed, sound-sealed enclosure, an encapsulated rotation to postcard epiphany; sites turned into sights and those sights visually itemised rather than bodily encountered. Up it inexorably goes, carrying the happy hamsters, far, far above the grunts and grinds of the town, far, far above London. What Virtue most hates about it – I'm guessing – is its name: the presumption of vision. What his paintings do is take on the hamster wheel; insist that Virtue's vision is the real London eye. Instead of detachment there is smashmouth contact; instead of mechanically engineered, user-friendly serenity, there is the whipsaw excitement of the city; its rain-sodden, dirt-caked, foul-tempered, beery-eyed, jack-hammered, traffic-jammed nervy exhilaration. Instead of a tourist fantasy, there is a place.

These paintings are punk epics: gritty; brazen with tough truth. You don't so much look at them as collide with them; pictures which smack you into vision. This is what all strong painting is supposed to do: deliver a visceral jolt, half pleasure-hit; half inexplicable illumination. It's what Rubens, Rembrandt, Turner, Francis Bacon, on top form, all manage. We gasp 'knock-out' and we mean it pugilistically; that we've taken a body blow. But instead of reeling groggily under the impact, we seem to have been given, Saul-Paul-like, a brand-new set of senses. We look at the world differently, we register experience differently, and we wonder how the hell this has been done, with something so economical as canvas streaked with paint; in Virtue's case *black and white* paint? And the answer is not to credit Virtue's paint with resolving itself into something we recognise as previously seen (even if that something is Nelson's Column), but rather to realise that those painted forms are themselves the material of new vision.

Virtue's work is a stunning reminder of what truly powerful painting can yet

achieve. The obituary of painting has been written so many times that declaring it premature has itself become a tedious piety. But the dirge drones on: the woebegone longing for the titans of yesteryear, for the Pollocks and de Koonings and Rothkos, under whose auspices paint, liberated from representation, did its own thing, was declared the Life Force. When the usual British suspects (Freud, Hockney, Hodgkin, Auerbach) are wheeled on for refutation of the Death of Paint, and the words 'vigorous' or 'constantly inventive' get uttered, it's with a note of gratuitous appreciation that the club of patriarchs can still turn it on, notwithstanding (it's implied) their veteran years and settled ways. There are, for sure, paint-handlers of prodigious power and originality around among the upstart young'uns – Jenny Saville; Cecily Brown; Elizabeth Peyton; and in a very different key, Rebecca Salter (notice the gender?), but it's also true that painting still seems to feel a need to make a case for itself against exhaustion. That it so often makes that case by ironising its relationship with photography – by fabricating images of such hyper-reality that their synthetic quality simultaneously owns up to the artifice of picturing while implicating photography in the duplicity – is just another symptom of painting's fragile confidence. Gerhard Richter, for instance, works in two minds and two moods: the one a defiant, slathering ooze of viscous abstraction; the other a more nervous and self-conscious dialectic with past masters (Vermeer and van Eyck) and with today's bad news. Anselm Kiefer, on the other hand, in his most recent metaphysical venturing, has increasingly needed free-standing sculpture and sculptural effect on his canvases if only in the cause of liquidating the formal boundaries between vision and touch.

'Pure' two-dimensional painting, at its most defensive, seems to have been boxed into a shrinking space between, on the one hand, video art and photography (against which a century ago it could unapologetically define itself) and, on the other hand, sculpture. If the nineteenth- and twentieth-century avant-garde was dominated by painting, with sculpture in an auxiliary relationship, specialising in monumental rhetorical statements whether Rodin or Henry Moore, Giacometti or Zadkine, the hierarchy in our own time seems to have been completely reversed. Whereas painting was once the medium through which the separation between the signs of the world and the work of art could be overthrown, it's usually sculpture these days which makes the most aggressively subversive moves. The fact that the definition of sculpture

(Richard Serra's torques but also Sarah Lucas's car wrecks constructed from unsmoked cigarettes) refuses nailing down, only adds more kick to its anarchic exuberance. Once the solid citizen in the studio, sculpture is now the wicked imp of invention. In Britain, its compulsive leitmotif is eros and thanatos, sex and death, but with death the runaway favourite, possibly because the practitioners of the morbid joke are far enough away from its reality to be able to imagine it as a real hoot. The favoured tempers in which these endlessly reiterated obsessions are rehearsed are elegy (Rachel Whiteread) and irony (Damien Hirst).

Irony-connoisseurs are going to have slim pickings amidst the heroically rugged work of John Virtue. For his paintings have been made as if much of contemporary art, or rather the *fashion* of contemporary installation art, had never happened, or at best are a facile distraction from more solidly enduring things. Good for him. Irony is poison to his passion, for his work draws not on death but life; in the case of the epic paintings he has made while looking at London, the life of a bruised city, caught in the warp of time. But the *élan vital* of Virtue's work also owes its strength to another celebration: of the life of paint itself. Which is why, when you look at a John Virtue, be it one of his 'landscapes' or his London pictures, you see more than the Exe Estuary or St Paul's Cathedral. You see John Virtue himself, in the act of painting, the work a permanent present participle of storming creativity. The modish word to describe such action is 'marks', but that implies discrete traces of remote activity. In Virtue's case, the more you look, the more you see the paint in a state of turbulent self-animation: dripping and drizzling, stabbing and dabbing, like a feverish sorcerer's apprentice. To say that Virtue and his work are unstoppable is to say many things, all of them apposite. But the most important tribute that can be paid to him is to acknowledge that in an art culture comatose from ironic overkill he has asked the straight question – what can paint actually do? And then he has set about supplying an unrepentant, triumphal answer.

Though Virtue's work is fashioned without any thought of the critics in his head, its implications are, in fact, momentous for the debate about the direction of painting in the digital age. The rap against Abstract Expressionism was always about its solipsism; the heady conviction that painting was no more than the manipulation of the materials which constituted it. It was at the point when freedom from figuration

– the adrenalin rush of egotistical all-over energy – turned into pseudo-spiritual loftiness, especially with colour-field stainers like Morris Louis and Barnett Newman, that those who yearned for modern painting to embody visual experience of something other than itself, began to complain of aesthetic asphyxiation. The take it or leave it upyoursish-ness of high abstraction, its priestly *noli me tangere* distance from social experience and from the indiscriminately raucous universe of signs, its warning notices posted against what it imagined to be the mindless crud of pop culture (movies, advertising, the whole gamut of capitalist gimcrackery) began to seem monastically barren. Against that visual scholasticism, on rushed the storming postmodernist carnival: Johns's flags and beer cans; Rauschenberg's shrieking collages; Rosenquist's wall-length Cadillacs and mustard-loaded hot dogs; Lichtenstein's comic strip *WHAAM!*. 'The world' as Leo Steinberg nicely, but demurely, put it, 'was let back in again.' How sad, then (and in retrospect, Warhol and his factory of stoned cuteness was a culprit in this) that work made as a breakout from narcissism, should somehow reinforce it, posing archly, relentlessly, mercilessly, the dullest question in the world: 'is it art?' Surely, and I say this imploringly, we no longer give a toss?

Certainly, John Virtue has more important things to care about, perhaps the most important of all being his move to make the dichotomy between modern painting and modern picturing moot. The party line for Abstract Expressionists (or at least their scribes and seers) could be summed up in a nutshell: the more painting, the less picturing there has to be; the *integrity* of painting depending, unconditionally, on the repudiation of picturing. By picturing I mean not just the attachment to description (for evidently that is not John Virtue's thing), but the evocation through the brush of something *about* a seen place, person or object. The seen something might not be the apparent surface characteristics of the place, person or object, so that the 'seeing' might be within the mind's eye, rather than a retinal report. So that we might well say that what John Virtue depicts is not London at all, but an idea of London, a sense of London (though not, I think, an *impression* of London). To acknowledge that much is not, for a moment, to compromise the 'reality' of how his eye, his hand and his paint coordinate, but on the contrary to insist that the reality they together make, the reality of a *painting* of London, is, in fact, the only reality worth having, at any rate in the National Gallery.

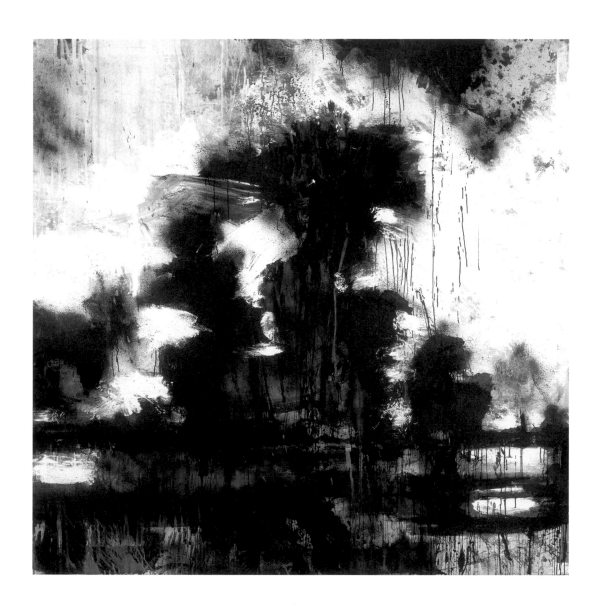

Landscape No. 555
1998, black ink, shellac and acrylic on canvas, 274.3 × 274.3 cm
Courtesy of the artist and Annandale Galleries, Sydney

What John Virtue has made possible is a reunion of painting and picturing, no longer in a relationship of mutual depletion, but something like the opposite – mutual sustenance. No-one standing in front of one of his big canvases could think that the force with which they deliver his vision could possibly be communicated in any other way: not digitally, not photographically, certainly not sculpturally. Nor, once seen, can that vision be subtracted from the sense of what London is, or for that matter, what painting is. In our visually over-surfeited but still mysteriously undernourished age, this is not bad to be going on with.

So what is it exactly that Virtue pictures? Well, nature, culture, history – that is, the history of his own craft as well as of the world – and the interlacing of them all in our visual imagination. Even on the evidence of the Exe Estuary paintings, he has never been a pastoralist. Cud-chewing serenity is not exactly the stuff of those roaring black and whites even when, ostensibly, they begin with solitary reflection. In 1958 Frank O' Hara did an interview with one of Virtue's heroes Franz Kline in which Kline also confessed himself to be incorrigibly in the stir of things, the artist telling O'Hara, 'Hell, half the world wants to be like Thoreau worrying about the noise of traffic on the way to Boston, the other half use up their lives being part of that noise. I like the second half, right?' Even when he has drawn by the side of a flowing stream or on a gantry swaying above the Thames, I think Virtue, too, is most moved by the buzz of the world; whether gnats humming in the tall grass, the gaseous tremble on the filmy pond or the pullulation of the urban hive. Instinctively, he draws no distinction between history and natural history. So too, like Kline again (and for those who rejoice at having spotted Virtue's 'source' in Kline's instinctual black-and-white visual operas, one need only quote Brahms congratulating those who detected a touch of Beethoven in the finale of his fourth symphony – 'any fool can see that'), 'I don't feel mine is the most modern, contemporary, beyond the pale kind of painting. But then I don't have that fuck the past attitude. I have very strong feelings about individual paintings and painters past and present'. Which, in Kline's case included on the positive side, Rembrandt, Bonnard and Toulouse Lautrec, and in Virtue's, Rembrandt, Turner, Claude Lorrain and Goya.

A catty little debate about Kline turns on the degree to which he is to be thought of as a purely abstract painter or rather as one among many in whose work traces of

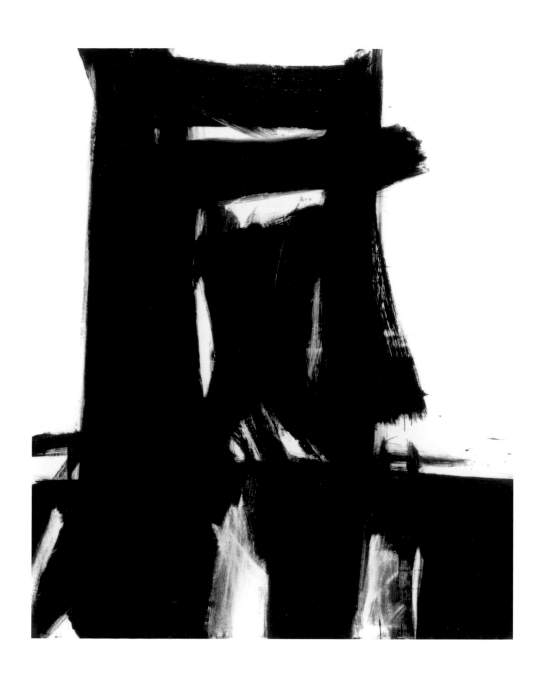

Franz Kline (1910–1962)
Meryon, 1960–1, oil on canvas, 235.9 × 195.6 cm
Tate, London, INV. T00926

figuration deliberately lurk; especially since titles like *Crow Dancer* might be read as a tease to identify primitive forms within the heavy onslaught of brushstrokes. But to participate in the quarrel is to miss the point about Kline since the force of his work is precisely to problematise the notion of 'pure' abstraction, and to translate seen (or felt) experience into an independent realm of painted gestures. *Meryon* (1960–1) may have started with the clock tower in Paris, mediated through a nineteenth-century engraver, but Kline's armature completes its Gothic ruin and resolves it into something elementally different.

Equally fruitless would be an argument about whether Kline, or for that matter, John Virtue, are painters of instinct or calculation, since the answer to both is yes. Much of the energy of Virtue's work does come directly from its improvisatory technique; so that the brush stroke seems always to have been freshly and urgently laid. Virtue is a draftsman through and through, yet the sweeping grandeur of his designs is less a matter of carefully calibrated delineation (the passages in his work I like the least are those where he makes linear architectural summaries, however freely rendered), but rather of his involuntary obedience to the accumulated patterning of a lifetime's working practice. His technique is painterly liberty guided by self-education. This makes him that rarest of birds in the studio, the wholly free disciplinarian.

In this complicated negotiation between chance and calculation, it so happens that Virtue has a revolutionary predecessor, the extraordinary eighteenth-century painter, Eton drawing master and print-maker, Alexander Cozens. In his moments of deepest perplexity (and there were many moments in his protean career when he was unperplexed and produced work of great banality), Cozens was exercised by the dissipation of the energy of the *idea* of a work, in the long process of its meticulous execution. This he thought a particular problem with landscapes, where a free sketch from nature would inevitably lose vitality as it was worked up in the studio, often at far remove in time and place from the drawn image, and, according to classical desiderata, guaranteed to drain away its spontaneity. (The phenomenally rich record of Virtue's sketchbooks documents not only the force of fleeting circumstances on his subject matter – light, wind, position – but also his determination to sustain that immediacy in the vastly amplified forms of the paintings.) Through serendipity (for him, the only blessed path), Alexander Cozens happened on a technique he thought might arrest

this fatal stagnation of energy and which he called, in a publication, *A New Method of Assisting the Invention in Drawing Original Compositions of Landscape*. Observing the accidental patterning made by a soiled piece of paper, and recalling Leonardo da Vinci's musings on the associative suggestiveness of streaked stones, Cozens, took this arbitrary staining as a cognitive tease from which to work up a fully-imagined design. In the *New Method*, the stains became Cozens's 'Blots', which provoked from his critics derision and the accusation that he was simply a charlatan.

Cozens was surely responding to Lockean theory about the initially unmediated force of sensory impression, as well as to the lure of the unfettered imagination, so dear to his friend the Gothick plutocrat William Beckford. But this did not make Cozens an entirely impulsive dabbler. His own description of the blots navigates carefully between intuition and calculation: 'All the shapes are rude and unmeaning as they are formed with the swiftest hand. But at the same time there appears a general disposition of these masses producing one comprehensive form, which may be conceived and purposely intended before the blot is begun. This general form will exhibit some kind of subject and this is all that should be done designedly.'

Cozens goes on to justify his *New Method* by claiming it helps stamp the *idea* of a subject (he means this, I think, Platonically, as the original abstract concept of a subject) and is even bolder (or more romantic) by writing that the preservation of that living Idea, is itself 'conformable to nature'. By this he does not mean there is a direct match between the concept of a representation and the objective facts of physical form, but rather something like the very opposite: that we are all prisoners (Plato and Locke again) of our machinery of cognition, and *that* is the proper form which the artist should seek to imprint on paper or canvas.

This may sound like an overly philosophical view of the modus operandi of so meaty a painter as John Virtue; yet it's surely not far from the mark. What Virtue gives us is not a visual document of London (in the manner, say of Wenceslaus Hollar) built from the accumulation of reported details, each in fastidiously gauged and scaled relationship to each other, so much as an overwhelming *embodiment* of London; closer to an East End pub knees-up; the trundle of an old bus grinding its way through the night streets; the peculiar whiff of fresh rain on rubbish-filled streets; the jeering roar of a stand at White Hart Lane (or Highbury); the brimstone glare of a line of Donor

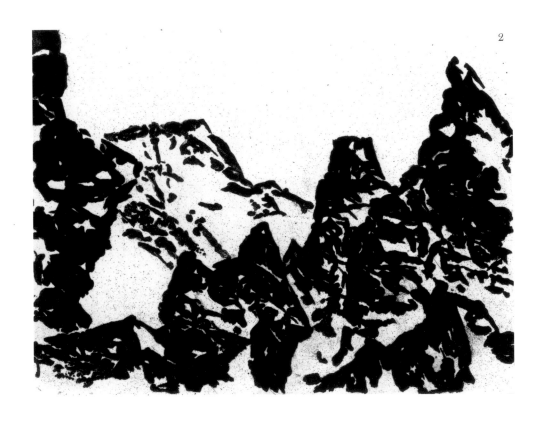

2

Alexander Cozens (about 1717–1786)
Aquatint #2 from *A New Method of Assisting the Invention in Drawing Original Compositions of Landscape*, 1785–6, drawing, 24 × 32.5 cm. The Victoria and Albert Museum, London, INV. 98291 E. 224-1925

KebabChickenFishnChippy takeaways – than to a Prospect by Canaletto. Virtue's St Paul's is not Wren's architectural 'gem', it's the pre-bleached grimily defiant mascot of Cockneydom: black, hulking, a bit thuggish. And just as he turns the bleached dome black, he equally stunningly turns the dirty old river white. But (as with Kline again), Virtue's blacks and whites aren't polarised absolutes: they drip and smear each other with gleeful impurity; much of the white flecked with a kind of metropolitan ashiness that gives the paint guts and substance; much of the black, streaky and loose, like road tar that refuses to set. His is, in fact, a smoky London, even if painted long after the epoch of the great pea-soup fogs. His vade-mecum is Dickens not Mayor Livingstone (though an earlier unreconstructed Ken would love these pictures).

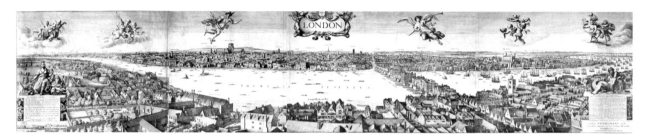

Virtue has often sung his ode to pollution; the artist's friend. Whether to embrace or reject the begrimed air, the half-choked light, has historically sorted out the men from the boys in London painters. Whistler loved it, of course, though he gussied it up as a dove-gray penumbra hanging moodily over Chelsea Reach. Claude Monet was in two minds about it, cursing it from his room in the Savoy in 1899 for blotting out the fugitive sun. Yet by far the strongest of his paintings – completed in a studio a long, long way from the Thames – were the greeny-gray early morning images of crowds tramping and omnibussing their way to work over hostile bridges, unblessed by even a hint of watery sunshine. The beatific tangerine sunsets which Monet inflicted on other paintings in the series, on the other hand, glimmer over the Houses of Parliament with an risible absurdity that could only be forgivable as the product of some mildly narcotic stupor.

Likewise, it's a symptom of their meretriciousness – their tyrannical prettiness, their utter failure to connect with anything that ever made London London – that

Wenceslaus Hollar (1607–1677)
Long View of London from Bankside, 1647, lithograph, 45.5 × 231.5 cm
Museum of London, INV. CL02/8799

almost all of the paintings produced between 1747 and 1750 by Giovanni Antonio Canaletto feature radiantly cerulean skies. It may just have been that Canaletto was lucky enough to work during days – we have them to be sure – of empyrean blue hanging over the Thames, but his obligation to sunny optimism extended beyond mere pictorial ingratiation. Canaletto was working for aristocratic patrons like the Duke of Richmond, heavily invested in the building of Hanoverian London, and whose education on the Grand Tour led them to reconceive the port city as the heir to Venice, Amsterdam or even Rome. Hence the earlier import of Italians to do London views – Antonio Joli and Marco and Sebastiano Ricci, for example – since their brief was to confect a fantasy metropolis in which classical memory united with commercial energy. Church façades bask in toasty Latin sunlight, the terraces of grand houses backing on to the Thames are populated only by ladies and gents of The Quality, and the river itself is barely disturbed by the occasional barge. Westminster Bridge, then under construction as a pet enterprise of the Duke of Richmond, was presented by Canaletto as a framing device, the Thames seen through one of its spectacular arches, both brand new and somehow mysteriously venerable in the manner of a Piranesi *veduta*. The truth, however, was that the bridge was hated by a good section of London artisans and tradesmen, particularly the watermen who saw in it their impending redundancy. As visual paradigms of the New London, then, Canaletto's display pieces were (unlike Hogarth's prints or John Virtue's paintings) emphatically not for the 'middling sort' of people much less the plebs. This aristocratic preference for poetic fancy over social truth reached a *reductio ad absurdum* with Canaletto's follower, William Marlow, painting in 1795 a *capriccio* in which St Paul's has been transplanted to a faithfully rendered depiction of the Grand Canal in Venice.

We tend to think of Turner (another of Virtue's heroes) or at least Turner the Brentford boy and happy waterman, as the antidote to all this Italianate picturesque contrivance. But of course Turner was as drunk on visions of Italy and Venice in particular as any of the *piccoli canaletti*, and was quite capable of turning out editions of the Thames which washed the scummy old stream in a bath of sublimity. And he was never above pleasing patrons, either. The direct ancestor of his 1826 *Mortlake Terrace*, now in the Frick Collection, painted for the nouveau riche William Moffatt, with its peachy light and strolling gentlefolk is, indeed, Canaletto, and beyond him,

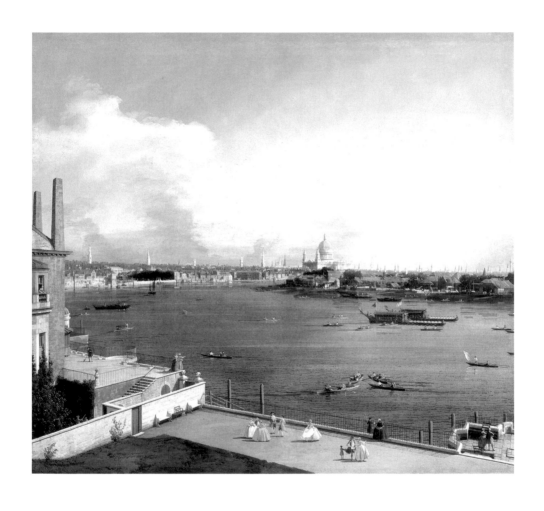

Canaletto (1697–1768)
View of London and the Thames, 1746, oil on canvas, 105.4 × 116.8 cm
The Trustees of the Goodwood Collection, West Sussex

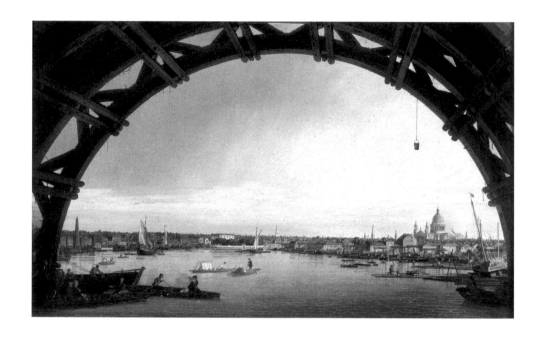

Canaletto (1697–1768)
London through the Arch of Westminster Bridge, 1747, oil on canvas, 79 × 186 cm
Collection of the Duke of Northumberland, Alnwick Castle

the Dutch city painters of the seventeenth century. Related concoctions like Turner's 1819 *Richmond Hill on the Prince of Wales's Birthday* or the 1825 watercolour of him sketching the serpentine curve of the river and the city about it from the summit of Greenwich Park, are best understood (and forgiven) as patriotic-civic allegories; omnia gathera of the memories, sentiments and loyalties called forth by the London prospect; but this time more in the nature of an implied historical pageant, insular and cocky rather than hybridised and Italianate. And, here too, the debt is more to the Dutch celebrations of the *genius loci* – Esaias van de Velde's wonderful *View of Zierikzee*, and of course Vermeer's Delft – than to a mechanical reiteration of Roman glories, both departed and resurrected.

At least Turner was struggling to marry up authentic Cockney Pride, an experience of place, with a re-imagined painterly aesthetic, rather than simply make the city a creature of swoon-inducing beautification; something which the punky smut of London will always, thank God, resist. It was not the American-ness of Whistler which led him to treat the river as aesthetic trance, but perhaps his permanent and increasingly desperate yearning to be in Paris, yet condemned to languish amidst the likes of William Frith and Augustus Egg as The American in London. The only way to survive was to flaunt it, and this Whistler did by becoming a painterly revolutionary in spite of himself, effectively annihilating his subject for a mood-effect. The rockets fall in gorgeous nocturnal obscurity somewhere, who cares, in the vicinity of Cremorne Gardens. The Gardens were a London pleasure haunt and a particular *bête noire* of John Ruskin as, of course, was Whistler himself and this painting in particular, for which the word effrontery seemed to the self-appointed guardian of visual truth to have been coined. But to make a Cremornian painting, to present art as epicurean delectability, a luscious dish for the senses, was precisely Whistler's point, one which, again, Paris might have taken as a compliment but which London found somehow (it couldn't say *exactly* how) indecent.

A great gap opened up in modernism, then, between London as the site of aesthetic cosmetic and London as the site of raw document; in the nineteenth century between the butterfly effects of Whistler and the reports from the underworld of Gustave Doré; in the twentieth between the visual histrionics of Oscar Kokoschka and in the 1950s the startling photographic streetscapes of the mind-blowingly gifted

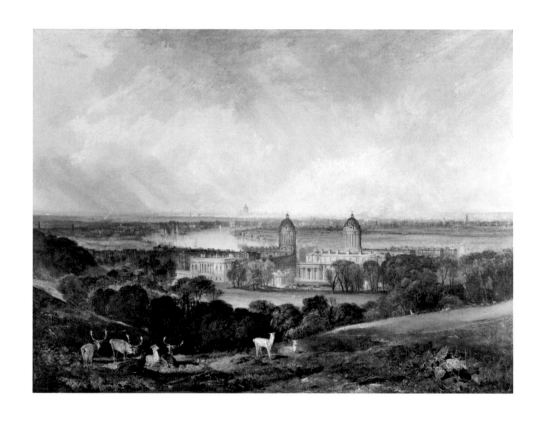

Joseph Mallord William Turner (1775–1815)
Thames from Greenwich Hill, 1809, oil on canvas, 90.2 × 120 cm
Tate, London, INV. N00483

Nigel Henderson. Leon Kossoff and Frank Auerbach did wonders in regrounding vernacular visions of the city in the worked density of paint, but even they were not quite ready to take on the totemic sights and memories of the war-ravaged city in the way Virtue, born two years after the doodlebugs had done their worst, could. (In fact, the spirit of painterly liberty in the 1950s had its own strong reasons to go nowhere near anything that could be thought of as paying lip service to a Festival of Britain-like cavalcade).

But that fastidiousness sealed off modernist painting of the city from the broader public whose need was, and may always be, celebratory, not darkly suspicious, or furtively pathological in the Sickert way. And it's the muscular innocence of John Virtue's picturing (along with the bravura of his paint-handling); his instinctive relish of the ant-heap swirl of London; his shockingly brave determination to make work which the untrained eye can immediately engage with, which has helped him achieve something no other painter of or in London has ever managed, a truly populist expressionism. That an entire ensemble of his huge, as well as his merely impressively large, paintings, should be hung together in the National Gallery as if in the Hall of Honour in the palace of some prince of Baroque, so that they are experienced as a cumulatively intoxicating rush of spectacle, only makes their deeply democratic quality the more miraculous.

But then Virtue has not been holed up like Monet in the Savoy Hotel, nor taking the morning air like Canaletto with the Duke of Richmond these past few years. Instead, he has been swinging from a gantry, or perched precariously on the roof of Somerset House, London's mean drizzle on his head; its cinders flying in his face; taking the measure of the city very like his cynosure Turner, in his non-Mortlake moments, right between the eyes. The fine frenzy that pushes Virtue along is wonderfully documented in his sketchbooks, but the challenge for him has always been somehow to transform those immediate responses in the studio into something that both registers and transcends its subject matter. In this most difficult of painterly goals he has, I believe, triumphantly succeeded, allowing us to read the great white daub at the heart of so many of his paintings as intrinsically related to its figural source in the Thames. At such moments of recognition, the pulse of the Londoners among us, especially, will race a little faster. But the reason to be most grateful for these epic

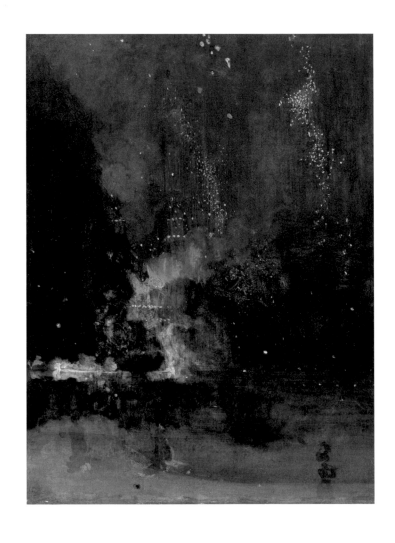

James Abbott McNeill Whistler (1883–1903)
Nocturne in Black and Gold: The Falling Rockets, 1875, oil on wood, 60.3 × 46.6 cm
The Detroit Institute of Arts, Detroit, Michigan. Gift of Dexter M. Ferry, Jr. INV. 46.309

masterworks is precisely for their resistance to visual cliché, even to cockney sentimentality; for their faithfulness to a London eye that actually sees beyond London. So we must also read the white daub as a white daub; the most thrillingly satisfying white daub conceivable, ditto the great racing black strokes; the gale-force whirl of the brush. Back and forth we go, then, through the picturing and the painting; the two in perfect step, doing the Lambeth Walk, oi! It comes as no surprise, then, to learn that that just happens to be where John Virtue lives.

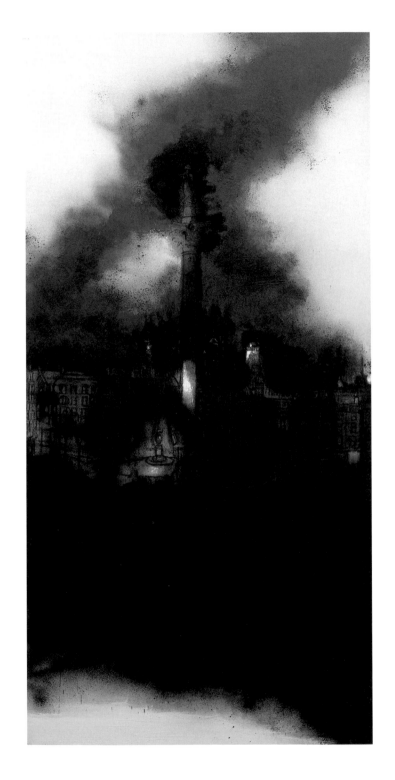

Landscape No. 713
2003–4, black ink, shellac and acrylic on canvas, 314 × 152 cm
Courtesy of the artist

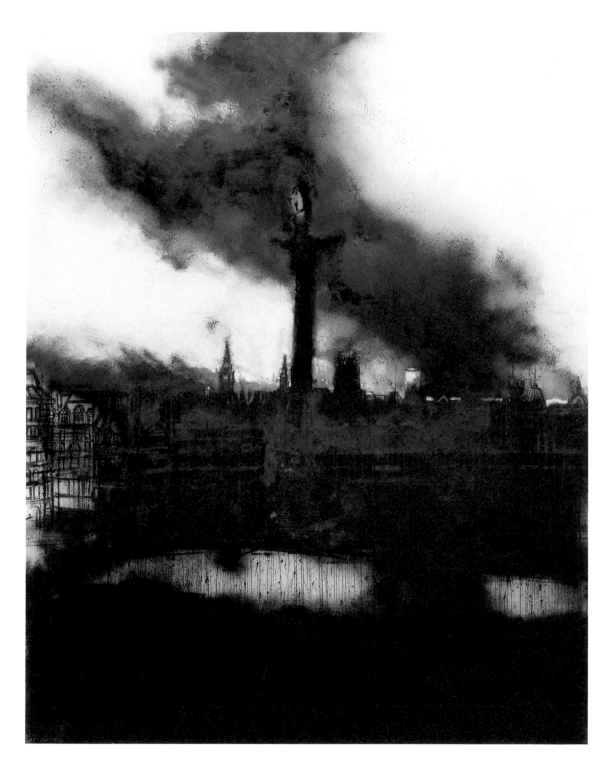

Landscape No. 759
2003–4, black ink, shellac and acrylic on canvas, 305 × 244 cm
Courtesy of the artist

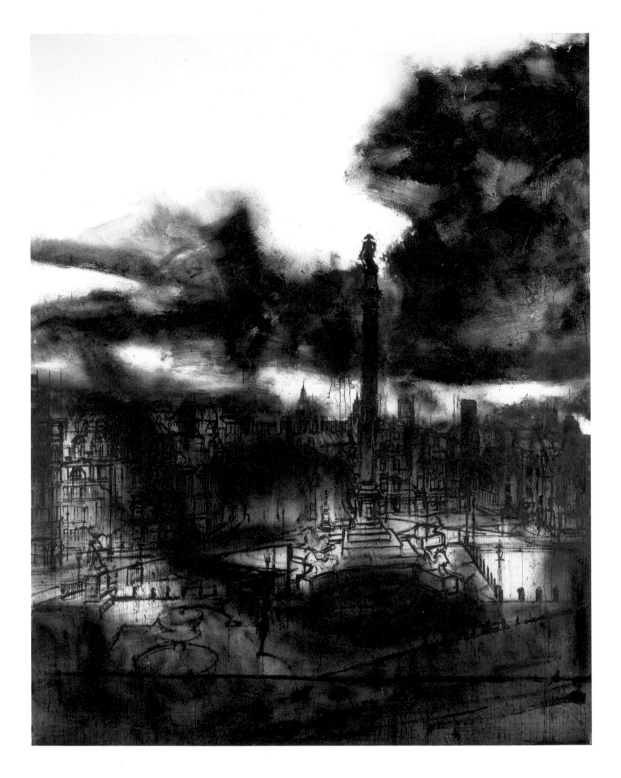

Landscape No. 738

2003–4, black ink, shellac and acrylic on canvas, 305 × 244 cm

Private collection, USA

IN THE MIDST OF LIFE – JOHN VIRTUE'S
IMAGES OF LONDON
Paul Moorhouse

For over a hundred and sixty years, Nelson's stony gaze has surveyed the constant stream of life swirling around the column that stands at the centre of Trafalgar Square. Since September 2003, John Virtue has been observing the same scene. Each morning, from his vantage point on the roof of the National Gallery, he has a bird's-eye view of the traffic flowing along Whitehall and the gradual filling of the Square with figures – a panorama of light and shadow, animated by the weather, constantly changing. Above, the sky expands to the ragged horizon of the metropolis, forming a vast elemental backdrop against which Nelson's solitary figure looks strangely exposed. The scene exercises a vital, resonant fascination for Virtue and he returns to it daily, recording his experiences in numerous, intensely worked drawings. Indeed, Nelson silhouetted in the midst of all this activity – human and natural – is the subject of three recent paintings by Virtue.

Two and a half years ago, Virtue came to London to become Associate Artist at the National Gallery. This was not, however, his first taste of life in the capital. He originally arrived in London over forty years ago, in April 1964. He was sixteen years old and the experience of seeing works by the great landscape painters has remained with him ever since, confirming and confronting his own development as an artist. From the outset, Constable, Ruisdael and Koninck were his guiding spirits; and, during the four years – from 1965 to 1969 – that he subsequently spent as a student in London at the Slade, these artists shaped his outlook and set his standards. No doubt they were also his demons when in May 1969 he rejected and destroyed all his student work. His entire output during the next nine years fared no better, this too being put to the sword in 1978.

Virtue was wrestling with and, it appears, sensing defeat by an apparently insuperable artistic problem: how to engage with a historic tradition – landscape – and even attempt to sustain and extend its achievements while avoiding the pitfall of imitation. Emulation or hubris? The path between these extremes is narrow and the way fraught with difficulties and questions. Since then, the course taken by Virtue's art has provided his enigmatic answer. During the last twenty-six years he has produced a

substantial body of work that challenges the very tradition from which it derives. In an individually numbered series dating from 1978, Virtue has produced over seven hundred images, each bearing the title 'Landscape'. At the same time Virtue claims, however, that he is 'not a topographical artist';[1] and, indeed, there have been times when his work has travelled far from the observed world, threatening to disintegrate into abstract shapes and energetic, even violent, brushwork. Of such works, Virtue has avowed that his activity acts as an 'armature' for concerns of a psychological nature. His decision to return to London to take up the invitation of a studio at the National Gallery is therefore intriguing. Unmistakably, he was placing himself and his work in the shadow of the artists he revered. But did this signal a will to renew or to subvert those historic landscape values that had originally fostered his art? And what of the paintings he has made in the last two and a half years – what is the topography that they evoke, if not that of London?

Topographical art is usually described as the making of images which depict places: towns and architecture, but also views of nature. It is differentiated from Landscape, which at times it resembles, by being principally concerned with giving information about the appearance of its subject, whereas the aim of Landscape is mainly aesthetic. Since his arrival in London, Virtue has been a relentless gatherer of detailed visual information about his principal subjects. Living initially at a hotel in Bloomsbury, each morning, without fail, he would walk to three sites in succession following an invariable route. Setting off before rush hour while the streets were relatively quiet, his journey would take him down Southampton Row, along Kingsway, around Aldwych, then over Waterloo Bridge. Depending on the tide and the weather, he would then either descend onto the mud at a site near the Oxo Tower or, failing that, he would take up a position on the jetty near the same spot. Both locations would give him an eastward-looking view of Blackfriars Bridge arching across the river, with the City beyond, clustered around the dome of St Paul's. This view is Virtue's first subject and by eight o'clock he would be drawing: committing the scene to paper, using pencil to make a painstaking and closely observed record in which the exact positions of the different buildings and the relationships between them are precisely noted.

From the South Bank, Virtue would then retrace his steps over Waterloo Bridge, arriving at Somerset House. Access to the roof of that building afforded his second

1 All statements by the artist are from an unpublished typescript of a filmed conversation with the author held at the National Gallery, London, 7 April 2004

subject: the huge, open expanse of the Thames snaking eastwards under the bridges at Blackfriars and Southwark and, beyond them, London Bridge and Tower Bridge. Here the scene spreads, taking in both banks, and placing St Paul's in relation to Virtue's own earlier position near the Oxo Tower. Once again, this eastward-looking view would be observed and recorded daily, Virtue returning again and again to the same scene, renewing the struggle to encapsulate its elusive, ever-changing appearance in the form of pencil marks on paper. Finally, he would return to street-level, advancing towards Trafalgar Square via Maiden Lane. By this time the morning would be well advanced, the streets' thronging rhythms in full flow. The day's drawing would be completed with an ascent to the roof of the National Gallery and a final, further engagement with the third of his subjects: Trafalgar Square with Nelson's Column at its centre.

Clearly there is a strong sense of ritual in the pattern that Virtue has established. Although his point of departure has now changed and the route modified accordingly, his routine is invariable: walking, drawing, walking and so on, day in and day out, as if etching his movements into London's streets, and at the same time piercing the appearance of his chosen sites ever deeper into the recesses of his mind. This obsessive repeated interrogation of particular views and his unquenchable desire to look again, look harder, look more deeply, are, it would appear, essential elements in Virtue's artistic ethos. The repetition imposes a structure that bridges life and art, opening up a passage between these opposite banks. In this respect, Virtue's perambulations around London are a vital part of his need to grasp a new, urban subject, but they also continue a discipline established at the beginning of his maturity as an artist.

Wherever Virtue has lived and worked, walking and drawing have been inextricably woven into the relationship he forms with his surroundings. Walks map out the passage of time, linking certain moments in the day or week with particular places, and the drawings made during those walks furnish and replenish information about certain sites. Both activities create a kind of architecture for his experiences. In 1978, Virtue was living in Green Haworth, a tiny Lancashire village whose bleak isolation fosters a kind of monotony that consumes the lives of its inhabitants if it is not itself consumed. At that time, he was earning his living as a postman, an occupation which inevitably involved him in regular, daily movement through his immediate

environment. At the end of the morning's round carrying a mailbag, Virtue would set out from his own house, following a network of routes that took him to a fixed pattern of locations. In the austerity of the sites to which he returned – walls, cottages, houses, an old Church, a Victorian Fever Hospital – Virtue found a richness that he could quarry.

It was around this time that he began to make small drawings in pencil and charcoal. The simplicity of his means of expression was attuned to the character of the motifs that increasingly came to preoccupy him. Also, having rejected completely the work he had done since moving to Green Haworth in 1971, the decision to restrict himself to minimal resources – no paint, no colour, reduced scale – was a way of beginning again. Drawing was a way of going forward, enabling a response to the subject that was relatively quick and portable, yet capable of conveying a wealth of information. He identifies the images that he made in Green Haworth after 1978 as marking the beginning of his mature work. Then – as now – the act of making drawings is an essential part of steeping himself in a subject. Through this repeated engagement, the character of a location is gradually revealed. The passage of time becomes an active element, different drawings revealing an endlessly expanding spectrum of changes in a subject's appearance, depending on the time of day and attendant variations in the light and weather. The drawings attempt to encapsulate this information. Even so, there is a sense that in Virtue's art this direct exposure to the subject has only ever been a beginning.

At Green Haworth, Virtue evolved a way of working which, in essence, remains unchanged to the present. This involves making drawings *in situ*, then using those drawings as the basis for a second, studio-based phase of activity. When he first adopted this procedure, at the end of each walk he would return home armed with the drawings he had made earlier that day. These would then be worked on further, the pencil or charcoal structure he had established on the spot being progressively covered by a dense thicket of cross-hatched lines, using pen and ink mixed with shellac. At the end of this subsequent stage, the appearance of the drawings would be entirely transformed, the pencil marks embodying direct observation now buried beneath a new surface of marks, made reflectively and at a remove from the initial experience.

This method is significant for it attests the complex relationship between the

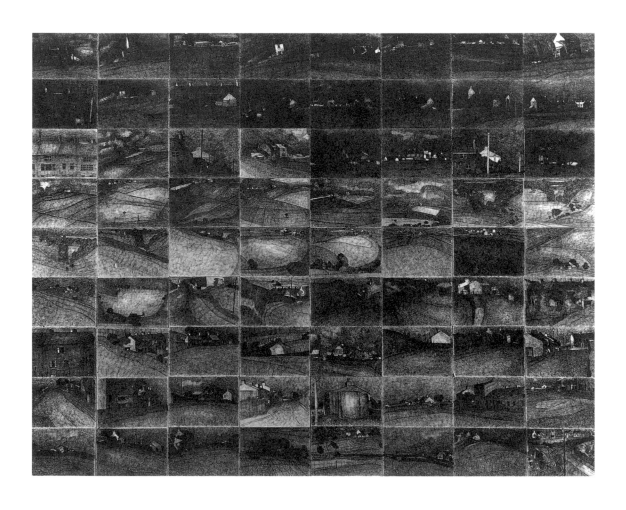

Landscape No. 7
1978–81, black ink, pencil, charcoal and shellac on paper, laid on board, 190 × 239 cm
Private collection, London

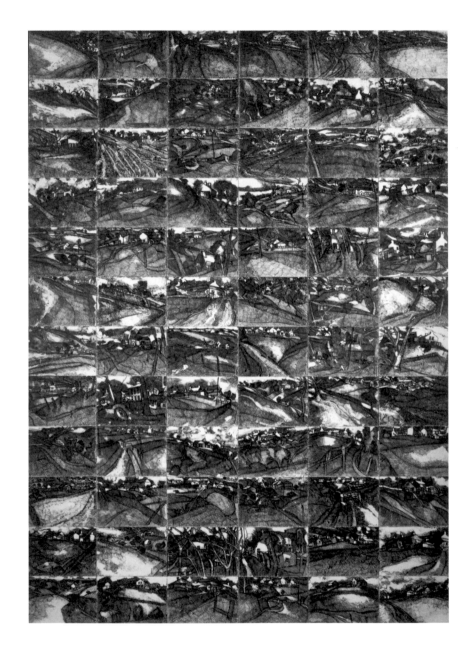

Landscape No. 40
1986, black ink, pencil, charcoal, shellac and gouache on paper, laid on board, 251.5 × 183 cm
Private collection, London

primacy of looking and then progressive *withdrawal* from topographical detail that stands at the heart of Virtue's work. Drawing on the spot fixes a structure for the size, shape and character of the elements within his field of vision. It creates a framework which, in the case of the Green Haworth drawings, supports a richly expressive, tonal chiaroscuro. The final image is thus a composite: embodying visual fact and the artist's subsequent response to those facts, in which feeling, memory and imagination are now implicated. Topography has yielded to something deeper, more personally resonant.

By 1980, Virtue had amassed a vast number of individual ink drawings of this kind. *En masse*, they formed a kind of ongoing visual diary, preserving each day's experiences; but these observations were disconcertingly fragmented and unconnected, their underlying logic defeated by the lack of unity. He then hit upon a way of bringing the images together. By combining the drawings so that they formed large tessellated compositions, the connections between them – different views of the same subject, made at different times – were revealed (PAGES 39–40). Individually, each small image presented a single view of a subject, but collectively these large mosaic-like formations offered multiple views. Presenting the drawings in this way more truly evoked movement through the world, the exposure to myriad impressions, and the passage of time – all essential aspects of seeing. With this device, Virtue shattered the monocular view of landscape which defined the work of Constable, Ruisdael and Koninck, replacing it with a faceted recreation of space in which different views of the same subject are presented simultaneously.

This innovation continued the progress of Virtue's work away from straightforward imitation of the observed world, emphasising instead a subsequent phase of activity in which his initial observations would be radically reconstructed. The tessellated compositions make this clear when they are seen from a distance. Individual topographical detail is embedded at a deep level, but is virtually impossible to read. Instead, within the overall surface activity the eye identifies shapes and points of light which appear almost abstract. Precise description has, as it were, been absorbed into a bigger visual argument in which the interplay of shape and tonality operates non-descriptively and in a more directly expressive way. The viewer steps back from the work to appreciate this effect and, in a sense, this is exactly what Virtue himself was doing in

the making of the works: finding the structure in the topography, then stepping back from that original subject and discovering new, unexpected levels of experience. Virtue pursued the implications of this way of working. By the time he left Green Haworth in 1987 he was attacking large areas of the tessellated compositions, using black ink and white gouache dripped and spread across the surface to efface parts of numerous underlying, patiently worked drawings. The effect was dramatic and not a little disconcerting – as if compulsive observation and some instinctive expressiveness were embattled.

The tension between these apparent opposites intensifies in Virtue's art from this point onwards, and it is an underlying, motivating force in the images that Virtue has made of London. As was the case in Green Haworth, the drawings that Virtue makes at his chosen London sites are never an end in themselves. As before, these *in situ* observations are brought to the studio. Unlike the images made in Lancashire, the urban images are not themselves then subjected to radical reworking; indeed they are not modified in any way. Rather, they are there for reference – as points of departure – for a process of ongoing reinvention which now takes place on canvas, on a greatly expanded and often vast scale. But whether working in Green Haworth or London, one element is central to both activities: the importance that Virtue attaches to responding to an image formed from direct observation. Underpinning that response there is the necessity of removing himself from the original experience, cloistering himself in the isolation of the studio, and then engaging with that topographical information through a prolonged, freely expressive process of re-creation – subjecting it to instinctive forces arising from within himself.

The creation of Virtue's paintings involves a process of progressive abstraction from natural appearances, but it would be a mistake to think that this was all. Abstracting implies a form of *incomplete* specification – the appearance of the observed subject has in some way been summarised or edited, distilled or simplified, so that the resulting image is a partial account. This is certainly true of his drawings. The sketches made of the City from the South Bank, for example, are in many instances both precise and summary. They accurately map out a complex network of architectural relationships and they do so with economy, condensing the individual buildings into incisive lines and forms. In that sense they serve a vital topographical

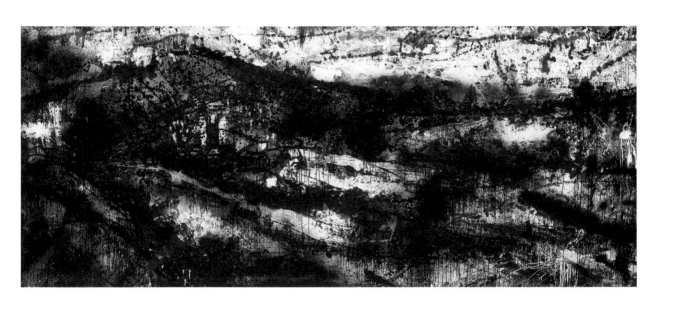

Landscape No. 148
1991–2, black ink, shellac, acrylic and emulsion on canvas, 230 × 480 cm
Collection David Bowie

function. But the paintings reverse this process. A work such as *Landscape No.704* (PAGE 93), is also packed with information. However, the message it conveys is primarily and essentially expressive. It communicates this through the dramatic massing of its looming shapes and the energetic animation of its surface, wresting an image of the City's architecture into a new, resonant pictorial logic. This cannot be explained simply as an abstraction *from* the appearance of the subject: something has been brought *to* it.

Virtue's art arises from the struggle between seeing and then, at a remove from the subject, responding to the image he has made. Though highly charged, this process is not a negative one. Indeed, he creates the necessary conditions for that engagement to occur. In the tessellated images, the friction between drawing and painting – between topography and a *projected* subjective response – was overt, threatening to tear the entire composition apart. In the works he has made since coming to London, the antagonism between observation and reinvention is no less cultivated, but more controlled. His progress towards marrying these conflicting forces – and, arguably, the power of the London paintings derives from his success in resolving these tensions – can be traced to the works made at South Tawton in Devon, and later at Exeter between 1987 and December 2002.

At South Tawton, walking, looking and responding were brought into close alliance. Dispensing with a primary drawing stage, the paintings were themselves made outdoors in front of the subject (PAGE 43). Working in the landscape, Virtue spread large, unstretched tarpaulin-like supports flat on the ground and then, using black ink, shellac, acrylic and emulsion, the images were committed directly to the canvas. During the painting process, he moved around on the canvas surface, impressing the evolving image with boot prints, mud and manure. There is a sense that this direct assault on the image in the presence of the motif was not only a subversion of those landscape conventions he admired. It was a way of fusing close, precise observation with an open, physical and freely expressive reaction – the forging of a link between incompatibles. In those unstretched paintings, there is the evidence of a transition towards a new kind of topography: one no longer simply to do with describing the external features of a landscape subject; rather, the creation of an image in which the presence of the artist is enmeshed.

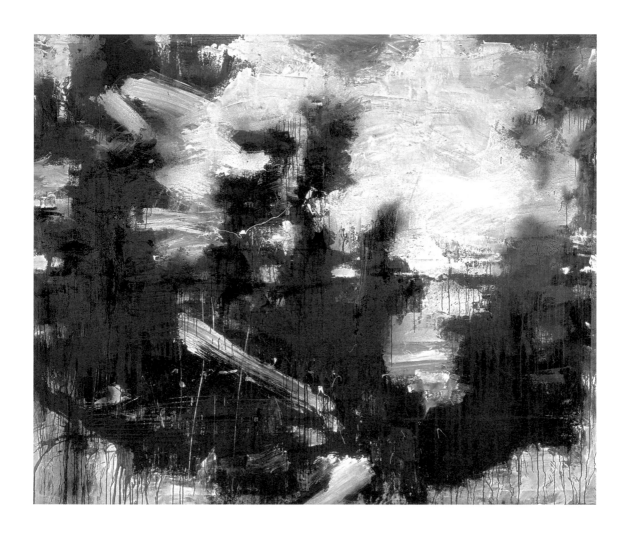

Landscape No. 508
1997–8, black ink, shellac and acrylic on canvas, 274.3 × 329.2 cm
Private collection, London

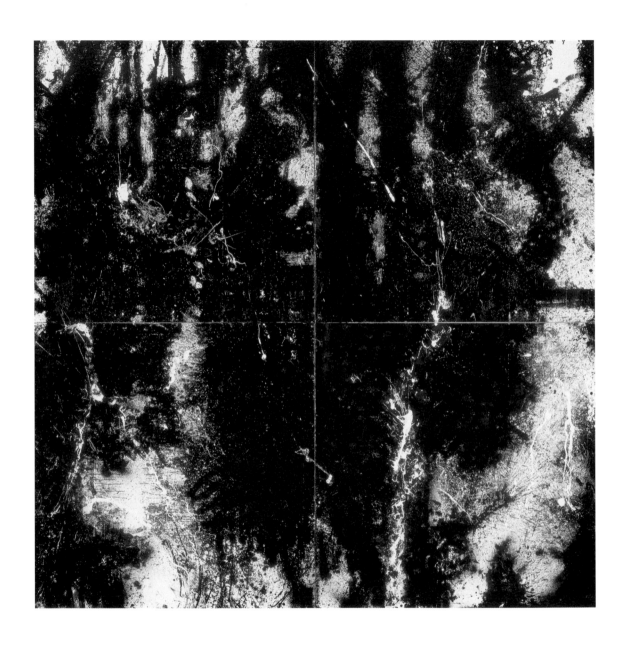

Landscape No. 624

1999–2000, acrylic, shellac and black ink on canvas, 366 × 366 cm

Tate, London, INV. T07915

The transition towards making images shaped as much by subjective forces as the landscape that inspires them, continued in the drawings and paintings of the Exe Estuary that Virtue made from 1997 until the move to London (PAGES 45–6). During this time, Virtue resumed his regime of regular walks, punctuated by stops at particular spots when a drawing would be completed. Following the course of the canal and river down the estuary, these images were the freest he had made to date. Invariably executed at high speed in felt tip pen, the formation of the image almost preceded the looking. Sometimes he changed hands; sometimes he looked away and carried on drawing. On occasion, rain or mist obscured the view, making any kind of informed observation impossible. Nevertheless, he still drew. The resulting images – and there were literally hundreds of them, many stained with rain so that the ink lines have bled and smudged – approached an extreme of abstraction. Now almost all destroyed, they were a precise empirical account: a record of the artist looking, thinking, feeling – existing – in the landscape at certain moments. For a while they fed the formation of paintings. Created in the isolation of the studio, the larger works on canvas continued the drawings' progressive removal from description, evincing a determined emphasis on shapes, marks and brushwork that operate in a more abstract, autonomous and personally expressive way. As such, they prepared the ground for the images of London.

Virtue left Exeter on 17 December 2002. In so doing, he turned his back on a rural subject that had occupied him continuously for five years: regular day-long walks once a week, several thousand drawings, hundreds of paintings of all sizes. The walk down the Exe Estuary had been a lonely one: the way is mostly overgrown with bushes and brambles and, apart from the birds and insects, there are few signs of life. This absence is evident in the images he made. He arrived at the studio that had been made available to him at the National Gallery on 6 January 2003, and immediately began to make drawings of his new surroundings. The walks in London that he then commenced connected him with a teeming current of human life, coursing through its streets. What is the connection between these two experiences? The answer is isolation.

Virtue's paintings of London arise from daily contact with a metropolis humming with life, experienced directly and at its centre. But the finished paintings are the outcome of a protracted, solitary, studio-based process of accretion and reflection. That process begins with drawings made on canvas; then, using ink, shellac, water,

emulsion and a bewildering battery of brushes and other implements, that underlying topography is progressively developed, revised, destroyed, recovered and, finally, left. During the evolution of each image the canvas fills with brushmarks, points of light, pools of shadow. Landmarks come and go, finding their right position. The Thames slides across the image, its bridges and jetties picked out against areas of reflection. The image begins to jell as light and dark fight it out. Buildings stand out from the blackness, still recognisable but sometimes barely discernible. Darkness courses through the city. Like a tissue of feeling it pulls the painting together, so that the individual parts begin to cohere. But there are no signs of life – except that of the artist, revealed in the vibrant surface of the painting itself. Whatever topography is now there, it is not only that of London.

Rural or urban, isolation is an essential part of Virtue's way of working. While the city rushes past, he seeks out solitude and finds it on the mudbanks, or in looking down into the crowd – and in the studio. Though situated at the hub of life and art, it is a place to be alone. There is something wilful in this stance, and its atmosphere permeates the paintings. Its importance for Virtue's art can be glimpsed by analogy. In the nineteenth century, the American intellectual and writer Henry David Thoreau carried out an experiment. For over two years, he spent most of each week living without company in a small cabin on the northwest shore of Walden Pond. This isolated site in the woods close to Concord, Massachusetts, was Thoreau's chosen retreat, a place set back from the city, closer to nature and, it seems, to himself. He recorded his thoughts and experiences in *Walden*, published in 1854. The book contains a moving passage in which he describes the experience of being alone at night, fishing in a boat anchored some distance from the shore of Walden Pond. In that setting – poised, as it were, between the vastness of the night sky above and the profound depth of the lake beneath – the writer would feel the occasional vibration on his line, and he would sense the unseen life lurking in the blackness beneath the surface. Then, with some difficulty, his hidden quarry would be pulled from the depths into the open air – a sudden, surprising intrusion of vital, thrashing life that interrupted his reverie. Thoreau observed: 'it seemed as if I might next cast my line upward into the air, as well as downward into this element which was scarcely more dense. Thus I caught two fishes as it were with one hook.'[2]

2 Henry David Thoreau, *Walden* (1854), reprinted Oxford 1999, p. 159

Virtue's drawings of London cast a line into the air. They attempt, repeatedly, to capture the fleeting appearance of a great city, a subject perhaps too large to be caught in this way. Virtue, himself, appears to acknowledge the impossibility of his endeavour. Transplanted to these new surroundings, he describes himself, disarmingly, as 'a tourist'. This strikingly honest observation reveals his acute awareness that London's memory cannot simply be opened up at will. He knows that in coming to this place, drawing is at best a scratching at the surface – a beginning. To go deeper, it is then necessary to stand back and look elsewhere. For this reason, he sees an absolute continuum between his earlier rural subjects and his engagement with London. The intense blackness that consumes these startling panoramas, and their rich, resonant monochrome tonality, can be linked only in a tangential way with Dickens's grime and the caustic breath of the city's traffic. Rather, Virtue's use of black and white goes back to his earliest work and is a link with his own past. It has always been a way of denying imitation of the visible world. It is a distancing strategy that allows the image – as a thing in itself – to speak. Now, as in the past, his studio has no windows that look outwards onto his subject.

For Thoreau, the effect of the sudden emergence of hidden life that he had been slowly raising to the surface was 'to link you to Nature again'. The dreamer was, as it were, connected, suddenly and intensely, with the exposed reality of his situation – alone, surrounded by forces visible and invisible, external and personal. In a curious echo of this observation, Francis Bacon, talking about his aims as a painter, explained: 'you unlock the areas of feeling which lead to a deeper sense of reality of the image, where you attempt to make the construction by which this thing will be caught raw and alive…'[3] For Bacon, the awareness of reality was deepened by using the process of painting to expose areas of experience which had remained hidden. Speaking of his own work, Virtue has observed that 'it is to do purely with the abstract forms and the making of a resonant image'. In the solitude of his studio, the artist turns inwards, and begins the process of casting a second line – proceeding from the drawings, then going deeper, beneath the surface of appearance, in search of that which is invisible but sensed.

Painting is the vehicle for this activity. The skeletal topography of the observed subject is put down on canvas, and then through the movement and accumulation

3 Quoted in David Sylvester, *The Brutality of Fact, Interviews with Francis Bacon* (1975), reprinted London 1999, p. 66

of marks, made freely and instinctively, the flesh of personal experience accrues. In the course of this process the image changes many times. The city skyline and the views of the Thames which initially appeared so definite, recede into half-light, disappear, are restated – over and over. The paintings relax their grip on description, moving increasingly toward a world of indefinable shapes, light and dark, surface traces of physical movement and energy. Gradually, however, the paintings acquire a new tautness as they take the weight of their catch. Finally, an image emerges – a vital, surprising, disturbing intrusion into the visible world – poised on the edge of recognition.

Virtue's art arises from opposition and paradox. Black and white, drawing and painting, description and abstraction, history and its denial – from these apparent opposites it derives its vital energy and its mystery. His London paintings concentrate these contradictions. They are both a complete break with his earlier rural subjects, and also a breathless continuation of themes embedded over thirty years ago. St Paul's, the City, Tower Bridge and the Thames: all are rendered through the eye of an acute observer who remains an outsider. At the same time, these are paintings of deep resolution. They take a historic tradition and wrest it into the twenty-first century. In that sense they are strangely timeless. Indeed, in his paintings of Nelson – a solitary figure amidst the clamour – Virtue has found an arresting and poignant metaphor for a universal human experience.

London Drawings

2003–4, pencil on acid-free paper, 26 × 37 cm

All courtesy of the artist

1 *Study from roof of National Gallery*
2 *Study from roof of Somerset House, looking east*
3 *Study from roof of Somerset House, looking west*
4 *Study from roof of Somerset House, looking south–east*
5 *Study from roof of Somerset House, looking towards Embankment*
6 *Study from roof of Somerset House, looking east*
7 *Study from roof of Somerset House, looking east*
8 *Study from the South Bank of the Thames*
9 *Study from the South Bank of the Thames*
10 *Study from the South Bank of the Thames*
11 *Study from the South Bank of the Thames*
12 *Study from the South Bank of the Thames*
13 *Study from the roof of National Gallery*
14 *Study from the roof of National Gallery*
15 *Study from the roof of National Gallery*

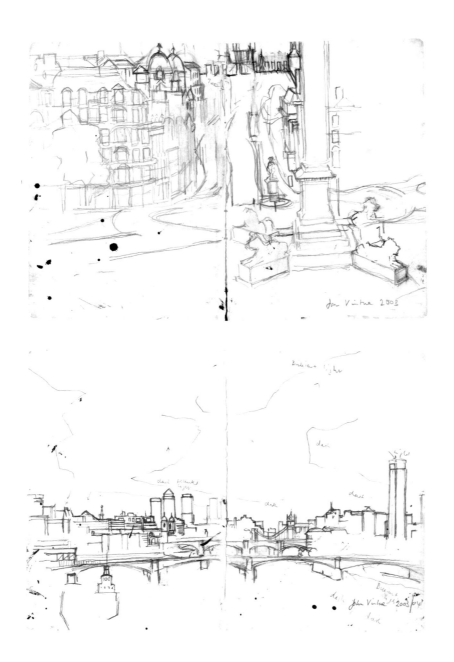

1

2

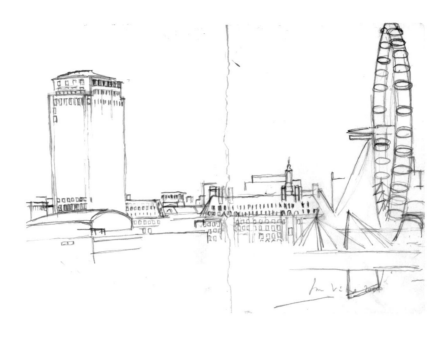

3

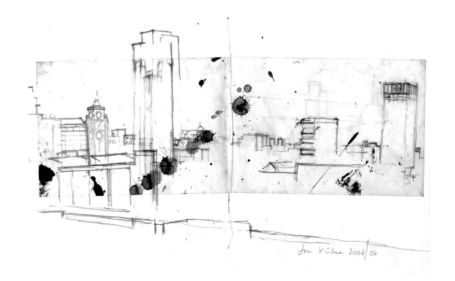

4

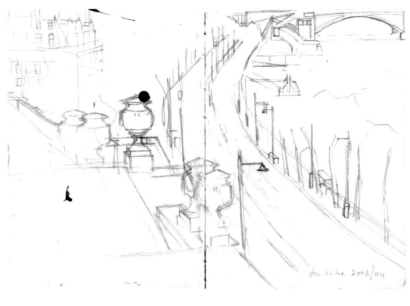

5

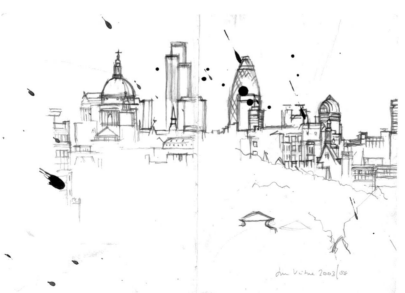

6

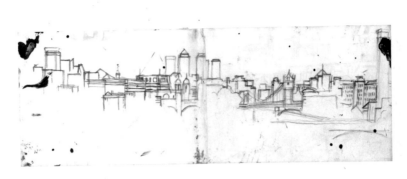

7

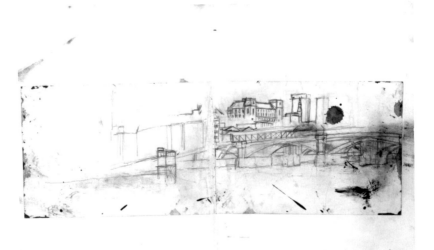

8

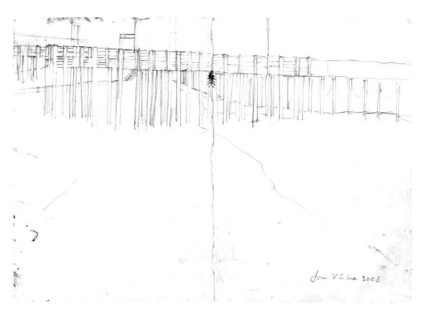

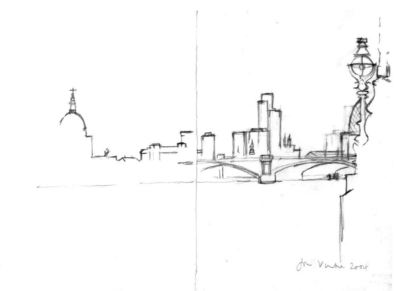

9

10

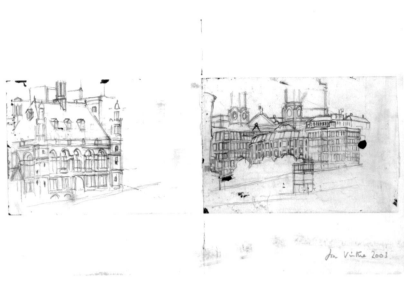

11

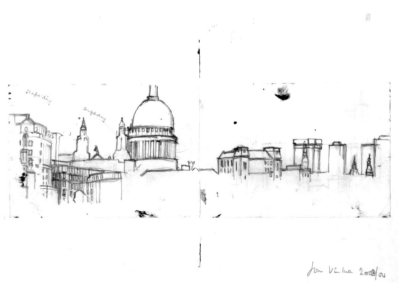

12

56

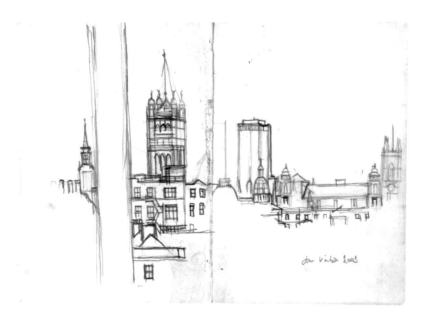

13

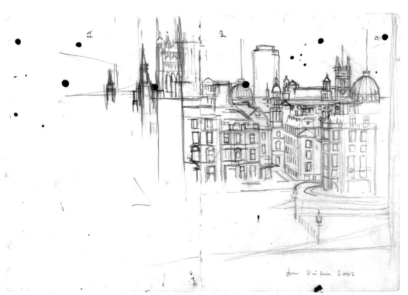

14

57

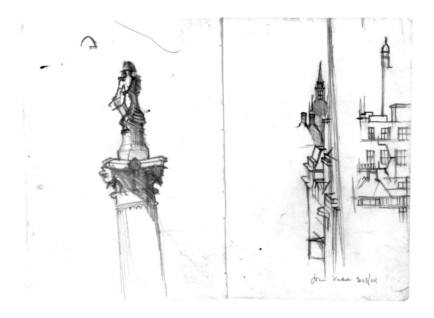

15

JOHN VIRTUE: LONDON PAINTINGS
Colin Wiggins

'A grey dusty withered evening in London city has not a hopeful aspect. The closed warehouses and offices have an air of death about them, and the national dread of colour has an air of mourning. The towers and steeples of the many house-encompassed churches, dark and dingy as the sky that seems descending on them, are no relief to the general gloom; a sun-dial on a church-wall has the look, in its useless black shade, of having failed in its business enterprise and stopped payment forever.'

CHARLES DICKENS *Our Mutual Friend* 1864–5

In February 2000 John Virtue, then living in Devon and working on a large series of paintings of the Exe Estuary, accepted the National Gallery's invitation to become its sixth Associate Artist. In December 2002, he moved into the studio at the Gallery to start work on the paintings that he had begun to plan as soon as he decided to take on the project. Virtue's work up to that time had been involved with the rural landscape of Lancashire and Devon. Now, he was to abandon the countryside and make paintings that tackled the sprawling historic cityscape of London, on a scale never before attempted by any other visual artist. Virtue had not previously considered cityscape as a subject and nor did anyone at the National Gallery imagine that he would undertake such a radical departure from his work of the last twenty years.

Virtue's relationship with the National Gallery runs deep. He vividly recalls his first visit as a schoolboy in 1964 when encounters with, amongst others, Gainsborough, Turner and Constable, left an enduring legacy. Echoes of Constable, for example, are evident in the Exe Estuary paintings. *Landscape No. 507* (PAGE 61) has the same pictorial structure as many works by Constable, the National Gallery's *The Cornfield* (PAGE 60) being only one example. More specifically, the tiny black vertical mark just below the centre of Virtue's painting, which represents All Saint's Church, Exmouth, plays an important role in the creation of space in the picture and is reminiscent of Constable's similar use of distant church towers.

This kind of relationship between landscapes of the past and the present made Virtue an ideal choice for the National Gallery's two to three year project, which

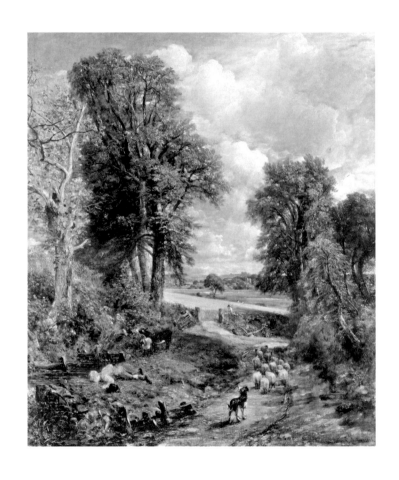

John Constable (1776–1837)
The Cornfield, 1826, oil on canvas, 143 × 122 cm
The National Gallery, London, INV. NG 130

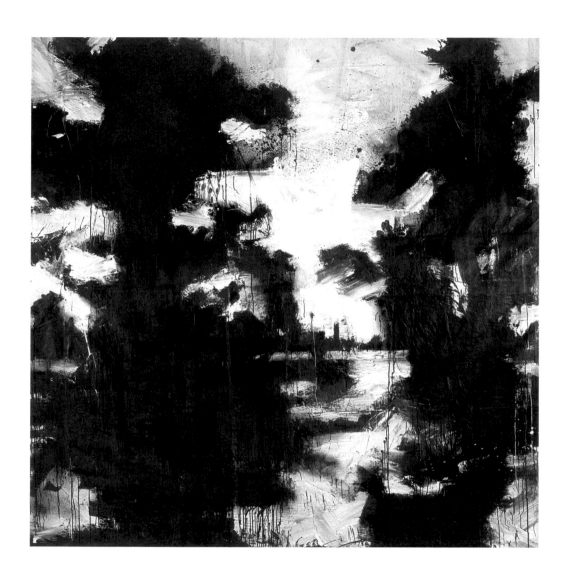

Landscape No. 507
1997–8, black ink, shellac and acrylic on canvas, 274.3 × 274.3 cm
Private collection, London

has the brief of using the collection as a point of departure for new work. Since 1978 Virtue had been engaging with one of the grand themes of the collection, the European landscape tradition that emerged in the seventeenth century with painters such as Ruisdael and Rubens, and reached its great flowering in England during the nineteenth century with Turner and Constable. Indeed, Virtue's relationship with this part of the collection can justly be described as obsessive. After accepting the Gallery's invitation, he asked to be supplied with black-and-white photographs of what he calls his ten 'hero paintings', works in the collection by Turner, Constable, Gainsborough, Rubens, Ruisdael and Koninck. These ten paintings have been a constant source of inspiration and provocation to him. Upon moving into his National Gallery studio, Virtue tacked these reproductions onto the wall directly by his painting area, together with two other photographs of paintings from the National Gallery of Scotland, one by Ruisdael and one by Koninck. While working, the artist only slightly had to redirect his gaze to see them. Their placing was perhaps less to act as a reminder of any particular formal values that Virtue could borrow for his own work, and more as a kind of talisman.

An unrealised project, suggested by Virtue shortly before he moved into the Gallery, was to display these twelve paintings together, without their frames, in a room at the National Gallery adjacent to his own exhibition. This idea was only abandoned due to practical reasons. Nevertheless, during his discussions with Gallery staff his obsession with these particular works forcefully revealed itself.

In addition to his fascination with European landscape, Virtue looks to other traditions. His pictures are executed in a modernist painterly language inherited from Abstract Expressionism. The gestural black-and-white compositions of Franz Kline are of great attraction to him, similarly the strict abstract severity of Barnett Newman and Ad Reinhardt. He also looks to Japan, and has a deep knowledge of the Zen calligraphers. A favourite is Sengai Gibon, whose *Shoki killing a Demon* (PAGE 64) demonstrates a deceptive fluency that Virtue finds inspirational. Volume, energy and movement are evoked with a series of apparently spontaneous marks. Indeed, Virtue's own painterly gestures can clearly be seen in relation to Zen calligraphy. His brushstrokes function powerfully as abstract marks, physical slabs of paint on a flat surface. But they can also be read as signifying trees, water, the

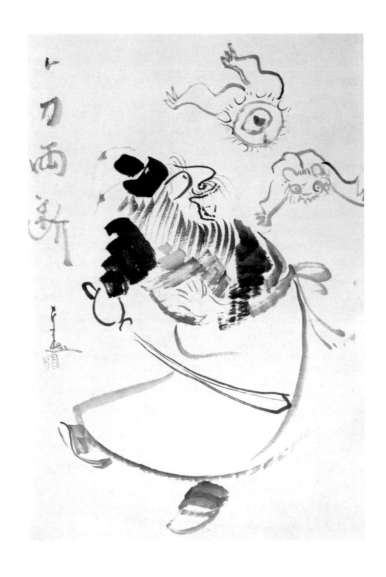

Gibon Sengai (1751–1837)
Shoki killing a Demon, after 1810, ink on paper, 86.4 × 58.4 cm
Private collection, USA

horizon or a distant church. He is fond of quoting from E.H. Gombrich's *Art and Illusion*, where Gombrich discusses a line drawing that can be read as either a rabbit with its long ears, or a duck with an opened bill. Gombrich points out that we can perceive it as either the rabbit or the duck, never the two at the same time. Taking his cue from this, Virtue insists that his paintings are made as reference-free abstract marks, but he then allows that they can become the topographical features to which they relate.

AT WORK IN THE NATIONAL GALLERY

Virtue's artistic biography is very simple. He studied at the Slade from 1965 until 1969. In 1978 he decided that nothing except his immediate landscape would be his subject matter. Indeed, it would perhaps be more instructive to say that he took a quasi-monastic vow to become a landscape painter. A strictly regulated, almost ascetic approach to his painting is a remarkable feature of the artist. For example, his interest in the Japanese Zen calligraphers is not limited to their works. The discipline of their lives, with monks dedicating themselves to their art for decades before they could consider themselves masters, is an enormously attractive idea for him and one he often brings into conversation. The limiting of his palette to black and white can perhaps be seen as an unconscious tribute to them. He also is an admirer of Frank Auerbach, whose near-mythic reclusiveness and reputed 364-day working year provide an almost ridiculous model of artistic austerity.

Despite the brief for this project, of using the collection as a source for new work, Virtue did not begin with any direct confrontation with specific paintings in the collection. Although he deeply admires, say, Constable and Turner, his manner of working demands an immediate engagement with a real landscape and not with any ready-processed pictorial distillation of it. Copying or transcribing from other artists' paintings is not a possibility for him. Virtue's dedication to landscape painting means that he has to go outside for his source material. He argues with conviction that his deep-rooted and long-term relationship with his so-called 'hero paintings' provides the necessary link with the National Gallery collection that enabled him to fulfil his brief.

Virtue's commitment to using his immediate surroundings as the focus for his work, combined with the fact of his new location, meant that there was no decision for him to take about the subject of the paintings he would be making in the Trafalgar Square studio. The organic, natural landscape of Devon was now literally and symbolically miles away. The central London cityscape was the only option. Virtue next needed to devise a new and characteristically rigorous pattern of working that would be strictly adhered to. Whilst making the Exe Estuary paintings, he would undertake weekly a sixteen-mile walk, right around the estuary, filling sketchbooks with rapid drawings. Whatever the weather, he would complete the sixteen miles, often with his sketchbooks and himself saturated with rain-water. This walk and its resultant images would act as source material for the next few days' painting.

For his two-year period as Associate Artist he constructed a new timetable. For the first year his family home was still in Exeter, which had been his base for the previous eight years. He would travel to London early on Monday morning and start his week's work in the National Gallery studio. At one o'clock on Fridays he would have what he called his 'weekly treat' and spend two hours in direct contact with the collection, choosing one or two rooms of paintings to study and enjoy, before returning home to Exeter for the weekend. On weekdays he would start the day by drawing outside, from two specific locations. The first was from the roof of Somerset House, overlooking the north bank of the Thames, facing eastwards towards the City of London. The second was on the South Bank at ground level, just in front of the Oxo Tower, also facing east. Nine months into this, he added a new location, the roof of the National Gallery. A long-felt reverence for Admiral Lord Nelson provided an unusual stimulus for *Landscape No. 713* (PAGE 32), *Landscape No. 759* (PAGE 33) and *Landscape No. 738* (PAGE 34), painted from drawings made overlooking Trafalgar Square.

Early in 2004 he left Exeter for good and moved up to London. Aside from the now redundant weekend journey to Exeter and back, his routine remained the same, with the two-hour Friday 'treat' of spending time in the collection retaining its timeslot.

When making his London drawings, as with the walks around the Exe Estuary, bad weather was not a deterrent. New drawings of the same views were made on every working day with the same buildings being drawn, often in fairly meticulous topographical detail, literally hundreds of times, indicating that for Virtue the need to draw

is not solely about gaining information, but is also to do with the desire to enact some kind of ritualistic procedure that bonds him to his subject, before starting the day's work on the paintings. These drawings are discussed elsewhere in this catalogue.

THE PAINTINGS FROM THE BASE OF THE OXO TOWER

Virtue works by setting a target and sticking to it, without allowing himself any slippage. Before he moved into the National Gallery studio, he asked to be provided with detailed plans of the Sunley Room, the proposed exhibition venue, so that he could decide the number, size and placement of the finished canvases in advance of the two years allocated to this project. There was no notion of beginning work, seeing what transpired and then selecting pictures to be shown. Two large-scale double canvases were ordered, 3 metres and 3.5 metres square, designed to be displayed as one image, with edges abutting, together with six single canvases measuring 2.4 metres square or more.

The contrast between the artist's previous rural surroundings and central London could not be greater. A quiet rural backwater was replaced by a busy metropolis. Trees became tower blocks. However, all this is incidental for his method of working. Virtue's stated view is that he is trying to make abstractions that derive from a visual reality. He is not consciously dealing with the history of a place and its peoples. For Virtue, narrative and anecdote are anathema. Consequently, while he is working, a black upright slab of paint is just that – a black, upright slab of paint. It is not an office block, a clump of trees or the tower of a distant church.

However, Virtue is the first to agree that London is emphatically not a neutral subject. By choosing to paint the view towards the City, following the flow of the Thames rather than looking back upstream towards Westminster, he was representing one of the most potent symbols of London and its history, the instantly recognisable dome of St Paul's. It is a subject that has been treated by many artists before and the decision to engage with it inevitably invites comparison with earlier images. For example, the unforgettable photographs that were taken during the Blitz in 1940, show the defiant Cathedral silhouetted against the black smoke of the Nazi firestorm. To a post-War generation, Wren's great dome is a symbol of the bloody-minded

Overleaf
St Paul's during the Blitz, 1940, photograph (detail)
Imperial War Museum, London, INV. HU 36220

character of London, emerging triumphant from disaster, as indeed the Cathedral itself had done in the immediate aftermath of the Great Fire of London in 1666.

The wartime photographs, like Virtue's paintings, are of course black and white. Virtue cites practical rather than theoretical reasons for rejecting colour in his paintings. Despite the artist's conscious intentions however, black and white can never completely shake off their psychological and symbolic resonance and inescapably have other implications. White is hope, life, light. Black is despair, death, darkness. As well as the two Turners in Virtue's compilation of National Gallery 'hero paintings', he has another Turner favourite that is not part of the National Gallery collection, *Peace – Burial at Sea*. This is a picture whose symbolism is undisguised. Made as an elegy following the death of Turner's painter friend and rival David Wilkie, it exploits the extreme contrast between the explosion of brilliant light that illuminates the scene, and the solid black of the ship and its dark reflection. It is easy to miss the telling detail of the dead painter's coffin being lowered into the sea at the side of the ship. Above it, the starkly silhouetted shape of the sail has an eerie abstract power that is a literal shadow of death. The brilliant areas of densely packed white pigment elsewhere in the picture, both in the water and in the sky above, function with similar metaphorical power.

We are confronted with comparably evocative black shapes in three paintings of Virtue's, called *Landscape No. 704*, *Landscape No. 705* and *Landscape No. 706* (PAGES 91–3). These are all painted on canvases 2.4 metres square and show views taken from the same position, the foot of the Oxo Tower on the South Bank of the Thames. When looking at reproductions of paintings by other artists, Virtue prefers black and white, not colour images. When seen in black and white, Turner's symbolic master-piece can readily be understood as a precedent for Virtue's three pictures. Typically, the black shapes in these new works function as both abstractions and topographical features. Each picture is very approximately divided into three horizontal bands. From the top downwards, the progression is sky – city – river. The central register, with its spiky and irregular geometry obscured by misty black veils of paint, clearly represents the London skyline. Identifiable buildings such as St Paul's, the NatWest Tower and the Swiss-Re Tower that has become known to Londoners as the Gherkin, are all clearly placed. Blackfriars Bridge spans the river, its structure reflected in the water

Joseph Mallord William Turner (1775–1851)
Peace – Burial at Sea, 1842, oil on canvas, 87 × 86.7 cm
Tate, London, INV. NOO528

below. The buildings and the bridge become a black man-made mass that thrusts angrily between two areas that are predominantly natural. Dark atmospheric effects animate the top part of the pictures, while energetic swirls and dribbles flow across the bottom, where the river itself is represented. The skyline is an agitated black shadow that imposes itself upon the luminescence of the white. In Turner's *Peace – Burial at Sea*, the black and the white – obvious visual metaphors for death and life – seem to be in balance with one another. In Virtue's paintings though, the black and the white seem to struggle for dominance. The black in Turner's poignant masterpiece has a gentle serenity. In Virtue's three paintings it looks threatening and vengeful.

Virtue is uneasy about such interpretations. However, on the open days that he held as part of his time as Associate Artist, he encountered many students and members of the public who commented upon the pictures in exactly this way. A common response was to find the pictures menacing or foreboding, apocalyptic even. Virtue's reply to these reactions was always the same: to state that he is simply making abstractions from the visual data he has recorded and he is certainly not attempting to invest the paintings with any kind of emotive content. He once conceded though, that 'I don't put atmosphere into my pictures but people seem to say it's there'. His stated reason for using only black and white is that he could never get on with colour in his work. He is attempting to convey a direct and tangible experience of the particular landscape that he is involved with. He finds colour is superfluous for his needs, as he strives to pin down what he calls an 'actuality'. Rejecting colour allows him to extract something essential from the views he paints. It is a stripping-down process, a near-minimalist approach that again prompts comparison with Zen calligraphy.

Amongst Virtue's favourite achromatic images from the history of art are drawings by Van Gogh and Seurat, two artists who are of course, great colourists. It is to their monochromatic works though, that Virtue is attracted. This does not imply a criticism of their paintings but instead demonstrates that Virtue's instincts lead him to an appreciation of structure and mass, of what lies beneath rather than on the surface. Seurat's *Place de la Concorde, l'hiver* (PAGE 74), for example, is dominated by the abstract upright of the lamp-post. It has a spare minimalism that finds a noticeable echo in Virtue's three Nelson paintings. Likewise, the etchings of Rembrandt are continually in his thoughts. In conversation he will often cite *The Landscape with Three Trees*

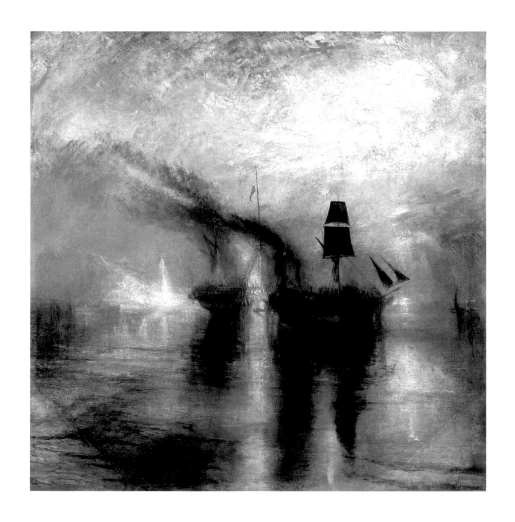

Georges Seurat (1859–1891)
Place de la Concorde, l'hiver (Place de la Concorde, Winter), about 1881–3,
conte crayon and chalk on Michallet paper, 23 × 30.8 cm
Solomon R. Guggenheim Museum, New York. Gift, Solomon R. Guggenheim, INV. 1941. 41.721

Rembrandt (1606–1669)
The Landscape with Three Trees, 1643, etching, drypoint and engraving, 21.3 × 27.9 cm
The British Museum, London. Bequested by George Salting 1910, INV. 29.107.31

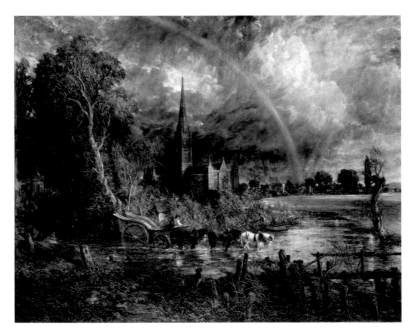

Joseph Mallord William Turner (1775–1851)
Dido building Carthage, or the Rise of the Carthaginian Empire, 1815, oil on canvas, 155.5 × 230 cm
The National Gallery, London, INV. NG 498

John Constable (1776–1837)
Salisbury Cathedral from the Meadows, 1831, oil on canvas, 151.8 × 189.9 cm
The National Gallery, London, INV. L47

(PAGE 75), a tiny yet epic composition that seventeenth-century Dutch Protestants would have interpreted as a disguised evocation of the Crucifixion. However, Virtue shows little interest in the art-historical interpretation of this print and sees it as a work profoundly successful in suggesting colour through achromatic means.

There are no people in Virtue's paintings. Humans have been excised from his compositions, another example of his tendency to strip down to essentials. The compositions of Virtue's 'hero painters', such as Gainsborough and Constable, always include what historians quaintly refer to as 'staffage'. Virtue's work however, remains eerily unpopulated. This is especially noticeable in *Landscape No. 709* (PAGE 99), an enormous canvas measuring 3.6 metres square. Virtue made the drawings for this painting whilst standing on the muddy foreshore of the river at low tide. Consequently the viewpoint is set dramatically low. The picture is divided horizontally by the wide span of Blackfriars Bridge, which separates the viewer from the buildings on the other side of the river. Despite their distance, the dramatic perspective allows these buildings to dwarf the spectator. This is reminiscent of a typical pictorial device used by topographers in the eighteenth and nineteenth centuries and one that Turner, for example, dramatically exploits in *Dido building Carthage*. Virtue's picture continues this tradition by making the viewer look upwards to the distant cityscape, which appears to loom forbiddingly in the distance. Turner's painting though, is teeming with busy figures. Human activity in Virtue's work is implied and not stated. On the far side of the river, the distant buildings become a dark and brutal monument to commerce. On the near side, a heavy black scaffolding of lines represents a construction of wooden piles used for mooring boats. Doubtless, similar features have been visible on the Thames since the first humans settled alongside it in prehistory. Virtue has rigorously observed this construction and placed each element with painstaking accuracy. It provides an area of abstract stability and plays a similar compositional role to the structure of Constable's 'rotting posts that I love so much' that he painted in his *Salisbury Cathedral from the Meadows*, one of Virtue's 'hero paintings'. And like the rotting posts in Constable's picture, the mooring piles in Virtue's painting hint poignantly at the lives of those anonymous men who put them there.

THE PAINTINGS FROM THE ROOF OF SOMERSET HOUSE

The pictures made on the north bank of the Thames, from the roof of Somerset House, are entirely different. In contrast to the work made from ground level in front of the Oxo Tower, these paintings are almost bird's-eye views. Two of these, *Landscape No. 710* (PAGES 106–7) and *Landscape No. 711* (PAGES 108–9) are large-scale panoramas, made by joining two canvases together. These are the largest works in the exhibition. We look down upon the great curving arc of the river and can follow its progress as it flows into the distance. Although tiny, the familiar landmark of Tower Bridge is unmistakeable, as the river flows out of our view. Slightly to its left, the skyscrapers of the Canary Wharf development are visible. In the very left foreground, Virtue includes a considerable area of the roof of Somerset House, on which he stood to make the drawings. Beneath layers of black, the classical urns that adorn the building are represented with the accuracy of an architectural drawing. They provide a sense of human scale in contrast to the great view that is laid out beneath us.

The size of these pictures, together with their broad sweep across the London skyline gives them an epic, visionary quality although they never lose touch with visual reality. By coincidence, while Virtue was preparing to take up his appointment at the National Gallery, an exhibition on the work of Turner's short-lived contemporary, Thomas Girtin, was on show at Tate Britain in the summer of 2002. This exhibition included studies for Girtin's now lost *Eidometropolis*, his huge 360-degree panorama of London. These works fascinated Virtue, inspired him even, as he prepared to begin his two-year project. Another coincidence was the National Gallery's own exhibition of the works of El Greco, which opened in early 2004. Included in the show was the celebrated *View of Toledo*, in which recognisable landmarks are set under a flashing and anti-naturalistic sky. In Virtue's London paintings, there is a similar tension between the topographical and the atmospheric, between the permanent and the impermanent. Indeed, in the larger of Virtue's two panoramas, *Landscape No. 711*, parts of the cityscape on the left, including St Paul's, are starkly illuminated as if by a sudden lightning flash, a pictorial effect that is strikingly Greco-esque.

Like St Paul's, the Thames has a powerful symbolism. Rivers have unavoidable and almost clichéd connotations of the journey through life, of our common mortality. Virtue's decision to paint the view that follows the flow of the river and not to look

El Greco (1541–1614)
View of Toledo, 1597–99, oil on canvas, 121.3 × 108.6 cm
The Metropolitan Museum of Art, New York. H.O. Havemeyer Collection
Bequest of Mrs. H.O. Havemeyer, 1929, INV. 29.100.6

Michael Andrews (1928–1995)
Thames Painting: The Estuary, 1994–5, oil and mixed media on canvas, 219.8 × 189.1 cm
The St John Wilson Trust, London

back towards its source inevitably provokes the same kind of symbolic reading that would be appropriate for the works of Jacob Ruisdael, one of Virtue's 'hero painters', whose pictures are loaded with Calvinist metaphors. This kind of symbolism is also present in the last works of Michael Andrews, paintings of the Thames that Virtue very much admires. Andrews made these paintings with the knowledge that he was dying of cancer and the final picture remained unfinished at the time of his death in 1995. Andrews's courageous images are potent in their meaning, both autobiographical and universal. In *Thames Painting: The Estuary*, the swirl of liquid pigments evokes the flow of the river on its inevitable progress towards its final union with the sea. Despite his deep respect for the work of Andrews, Virtue is resistant to having his own paintings discussed in a similar metaphorical way. However, the black sheets of paint with which Virtue shrouds the city's buildings, elicit a similar sense of the inevitable. The great metropolis is literally and metaphorically overshadowed by the irresistible dark forces that loom above it, and is split in two by the band of white energy that flows through it. Another work of Andrews that Virtue admires is the melancholy and mysterious *Edinburgh (Old Town)* (PAGE 83) where detailed architectural observation vies with the loose veils of colour that threaten to obscure it, in a manner remarkably similar to Virtue's own way of painting.

In choosing to look downriver, Virtue is of course following artists such as Monet, Derain and Kokoschka, but any resemblance to their work is superficial. More instructive is comparison with the London views of David Bomberg, such as *St Paul's and River* (PAGE 85), made during the 1940s when Britain was still at war. Bomberg's mantra of 'The Spirit in the Mass' is amply testified in these drawings, which were produced with the desire of stripping down to essentials. Although Virtue responds positively to Bomberg's charcoal drawings he rejects the possibility of any influence. He holds similar views about the London landscapes of Bomberg's former pupils, Leon Kossoff and Frank Auerbach. Indeed, his relationship with these two artists predates his time at the National Gallery. Auerbach and Virtue have been corresponding since 1969 and Auerbach wrote a catalogue introduction for Virtue in 1999. Virtue and Kossoff first met in 2000. When Virtue began work on his Thames paintings, Kossoff wrote a long supportive letter to him, in which he pointed out that the young Charles Dickens had had his unhappy formative experience of working

in a blacking factory to pay off his imprisoned father's debts, alongside that very same river, by Hungerford Steps. Indeed, London as a subject has perhaps been more fruitful for writers rather than for painters. Whilst working towards his National Gallery exhibition, Virtue carefully read and enjoyed Peter Ackroyd's acclaimed *London: The Biography*. Ackroyd, like Charles Dickens before him, understands the city as a huge living, breathing and evolving organism. Virtue found Ackroyd's book utterly compelling and admits that it affected the way he viewed the city that had now become his subject matter. In his biography of visionary Londoner William Blake, Ackroyd memorably describes Blake's poetry thus: 'it embodies an art that is preoccupied by light and darkness in a city that is built in the shadows of money and power…' This romantic description seems to be equally applicable to Virtue's London paintings. The shadows that hang menacingly above his skylines have that same visionary and metaphorical quality that is found in Blake's poetry as if, in Ackroydian terms, the city of London is imposing its own personality upon those who live in it.

Dickens himself, when writing of London in *Our Mutual Friend*, also uses a visionary language that seems appropriate to Virtue's black-and-white paintings. 'It was a foggy day in London, and the fog was heavy and dark. Animate London, with smarting eyes and irritated lungs, was blinking, wheezing, and choking; inanimate London was a sooty spectre, divided in purpose between being visible and invisible, and so being wholly neither.'

Dickens is of course referring to the industrial coal-produced pollution that shrouded and choked nineteenth-century London. When making his drawings, Virtue was often struck by the beauty of the sunlight as it struggled to penetrate the pollution of twenty-first-century London and this has inevitably found its way into his paintings. Looking closely at the surface of this new work, the Dickens reference seems especially pertinent. Much of the architecture is indeed 'between being visible and invisible'. Virtue's working method is to carefully delineate all of the buildings, window by window, chimney by chimney. All of this detail might then be completely or partially obscured by veils of black. The process is cyclical. These black layers in turn might then be covered with dense white acrylic, enabling the artist to carefully redraw the architecture, which will once again be buried. Virtue employs a wide variety of mark-making methods. Using the point of a small brush, the fine

Michael Andrews (1928–1995)
Edinburgh (Old Town), 1990–1, oil on canvas, 183 × 274.3 cm
The Scottish National Gallery of Modern Art, INV. GMA 3697

architectural details that have been noted in the drawings are transcribed with care. On the opposite extreme, a whole bucket of black ink might then be emptied over the picture from a distance of several feet, sometimes with the painting on the floor. Over the years Virtue has accumulated a large collection of different brushes, many from China and made from various materials, using hairs from sable, horse, bear or goat. He uses cans of spray-paint. He wipes and smears with J-cloths and employs a whole variety of implements and methods to obtain a wide range of different kinds of marks.

Aside from the double canvases, two other paintings were made of the view from the roof of Somerset House. In *Landscape No. 708* (PAGE 97), St Paul's, the NatWest Tower and the Gherkin can all be picked out in the centre of the picture. Immediately beneath although nearer to the foreground, is a starkly lit area of fine architectural detail. The rigorous, controlled geometry of this part of the painting is in great contrast to the dense black veils that shroud the rest of the work. On the right, a shimmering chevron of white represents the river as it flows towards the silhouette of Blackfriars Bridge. Most of the lower section of the painting seems to descend into shadowy darkness, once again making it very difficult for viewers to resist a romantic interpretation. In *Landscape No. 707* (PAGE 95), the Thames is given a greater role. The curve of the Victoria Embankment follows the course of the river. The brightly illuminated architecture in the centre represents the development of modern apartments at Blackfriars and, seen pushing upwards behind them, is a tiny black upright that represents the Monument. Despite its relative smallness – it is only about 3 centimetres high – in a painting that stands at over 2.5 metres, and despite Virtue's resistance to such interpretations, this has an important symbolic role, because the Monument was built by Sir Christopher Wren to mark the exact site of the outbreak in 1666, of the Great Fire of London, that engulfed the medieval city.

This painting, like London itself and like all of Virtue's new work for this exhibition, is built layer upon layer, with previous images buried but still occasionally revealing themselves through the translucency of subsequent layers. A symbolic connection with the history of the city is unavoidable. Each generation of London's inhabitants leaves a mark on its appearance, which either survives for posterity or becomes buried underneath the accretions of subsequent generations. Norman is piled upon Saxon, Roman upon Celtic, back to the first people who settled by the river. The city has been

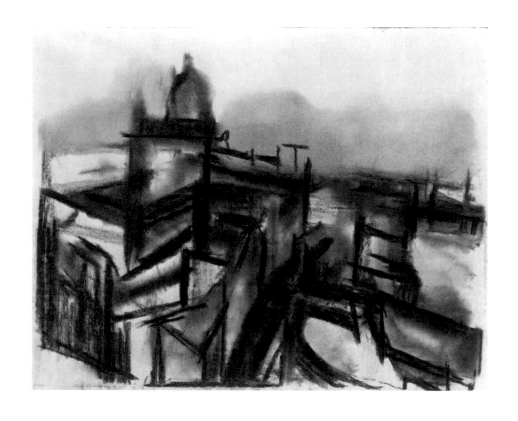

David Bomberg (1890–1957)
St Paul's and River, 1945, drawing on paper, 50.8 × 63.8 cm
Tate, London, INV. T01964

burnt and rebuilt, blitzed and rebuilt, with the only constant feature being the river Thames. During his time at the National Gallery, the Thames became Virtue's leitmotif. The fluctuating weather and the slowly changing London skyline, marked during this two-year period by the completion of the Swiss-Re Gherkin Tower, provide a contrast with the constantly flowing river, which provides the one note of permanence. It was of course alongside that river that the first human inhabitants of what was to become London chose to make their settlements, thereby beginning the countless generations who have contributed to its development and evolution. Virtue's paintings record that evolution and at the same time, become part of it.

LONDON PAINTINGS

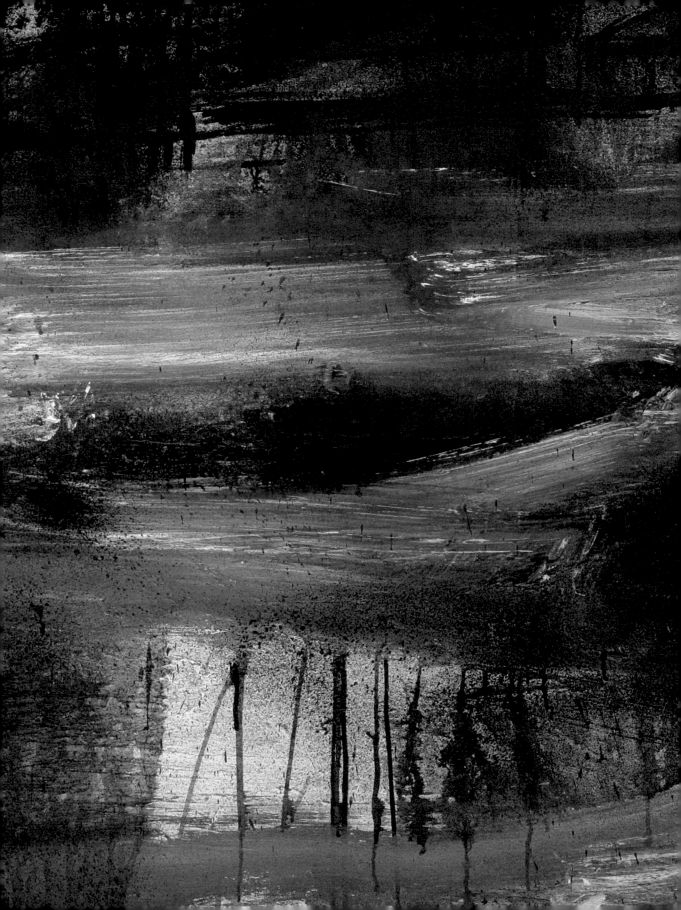

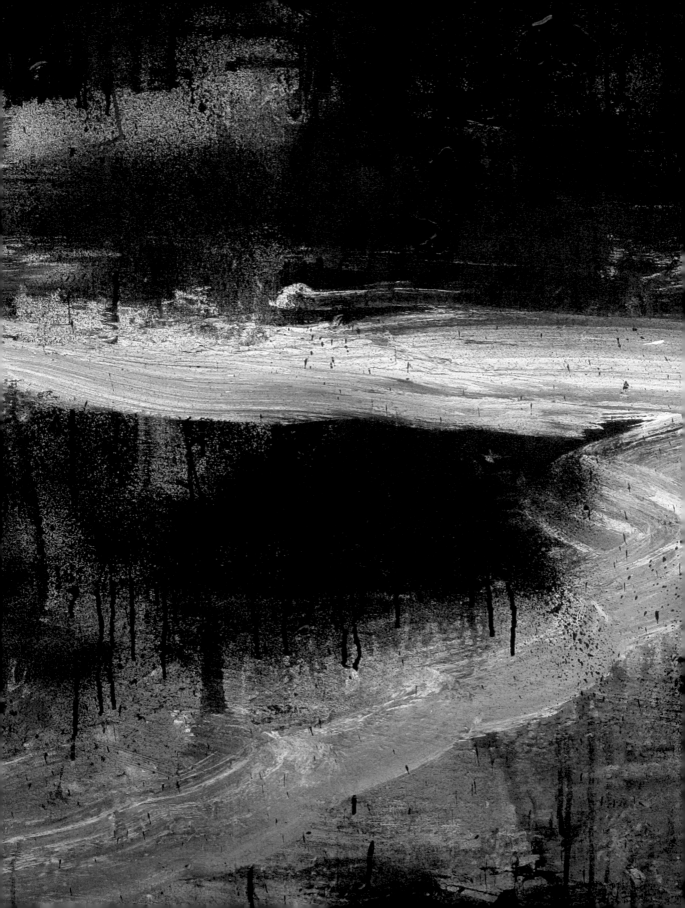

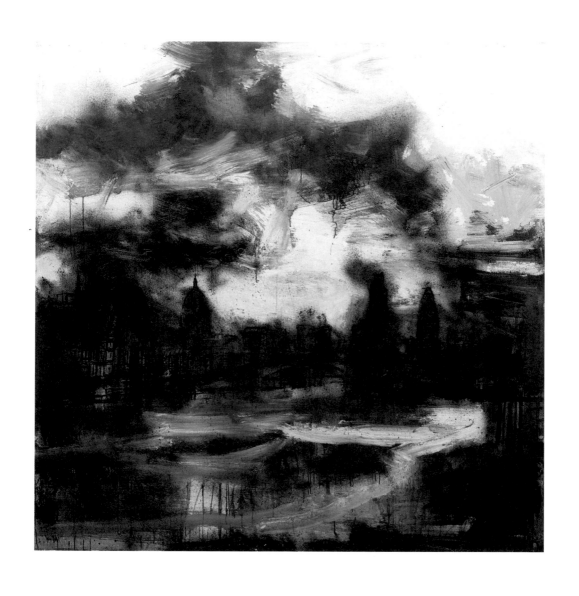

Landscape No. 705
2003–4, acrylic, black ink and shellac on canvas, 244 × 244 cm
Courtesy of the artist

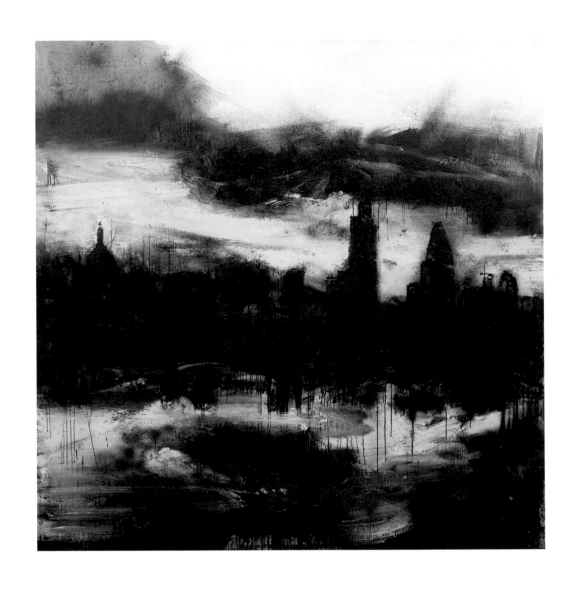

Landscape No. 706

2003–4, acrylic, black ink and shellac on canvas, 244 × 244 cm

Hiscox plc, London

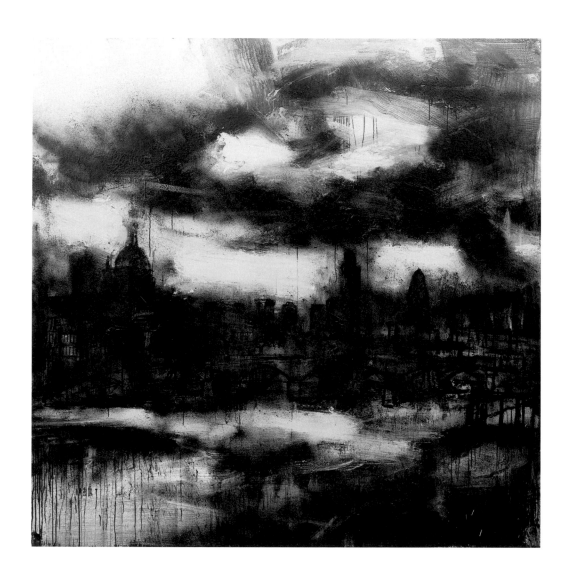

Landscape No. 704
2003–4, acrylic, black ink and shellac on canvas, 244 × 244 cm
Courtesy of the artist

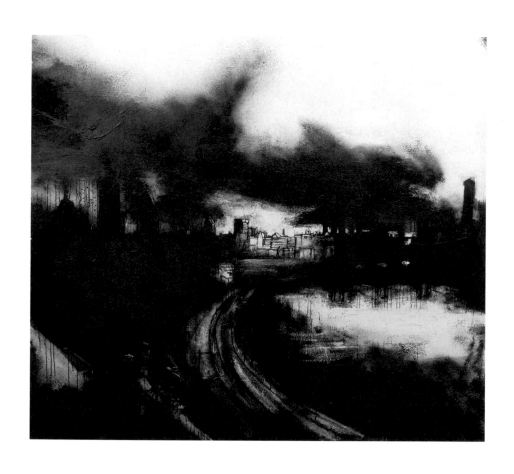

Landscape No. 707
2003–4, acrylic, black ink and shellac on canvas, 244 × 274 cm
Courtesy of the artist

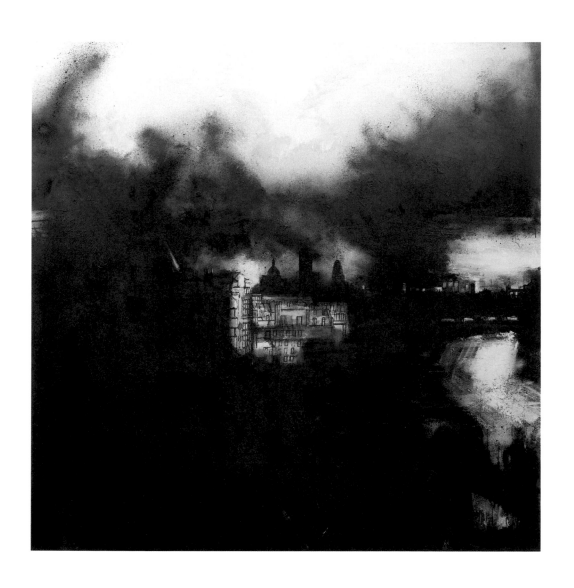

Landscape No. 708
2003–4, acrylic, black ink and shellac on canvas, 305 × 305 cm
Courtesy of the artist

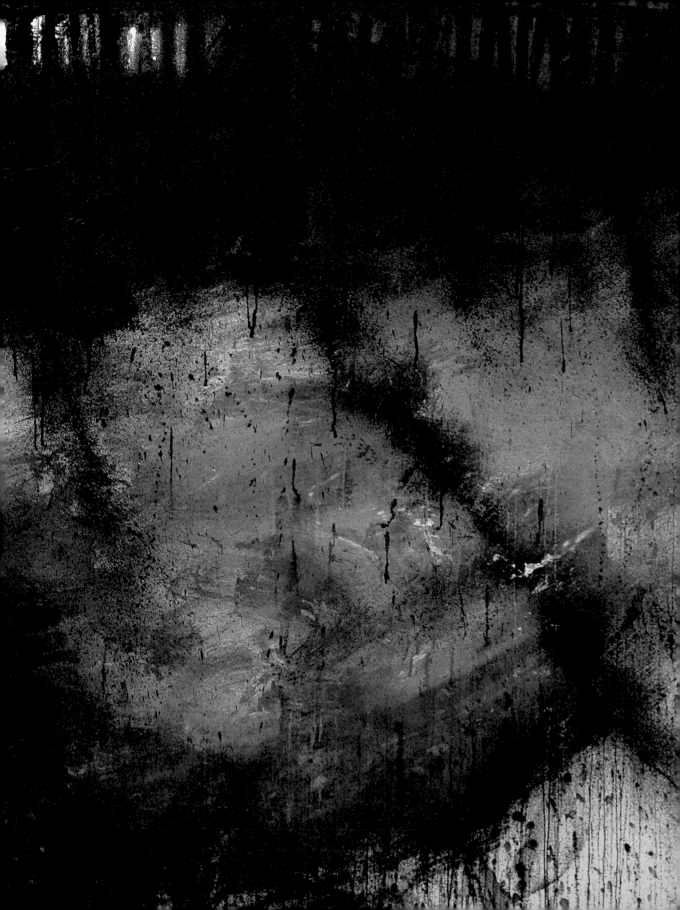

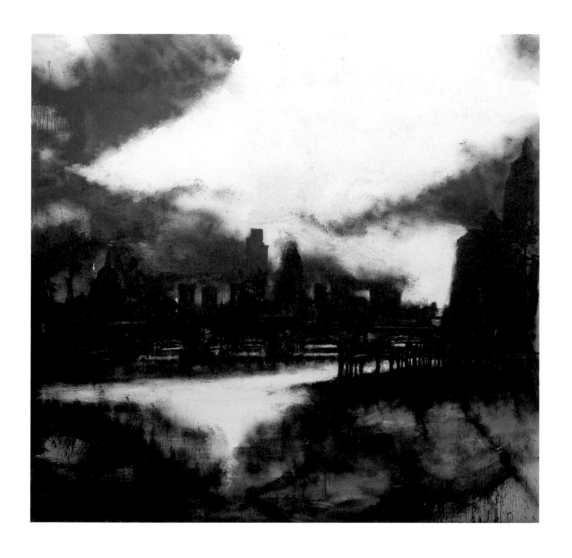

Landscape No. 709

2003–4, acrylic, black ink, and shellac on canvas, 350 × 366 cm

Private collection, New York

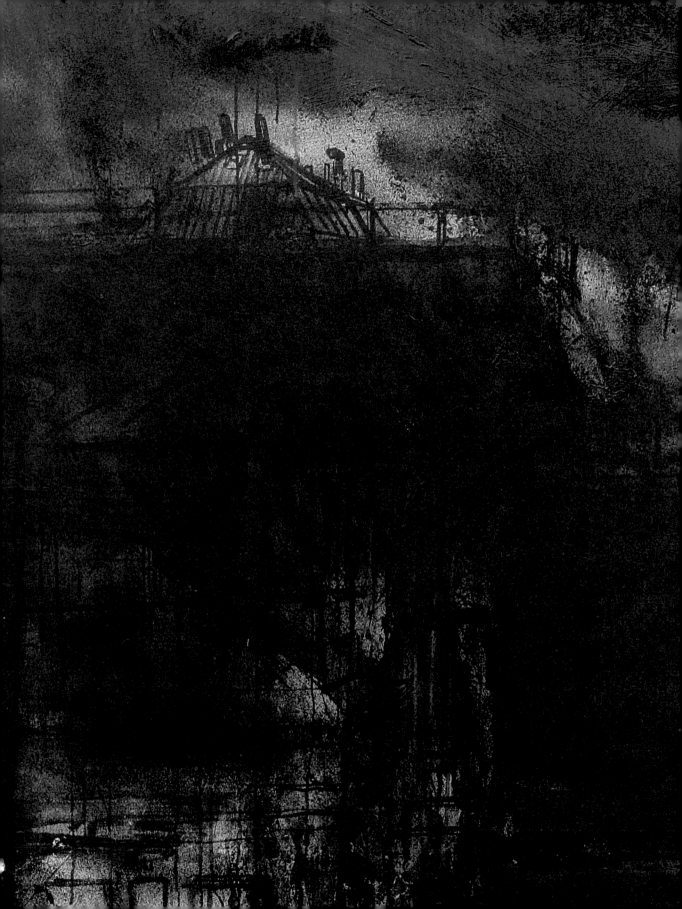

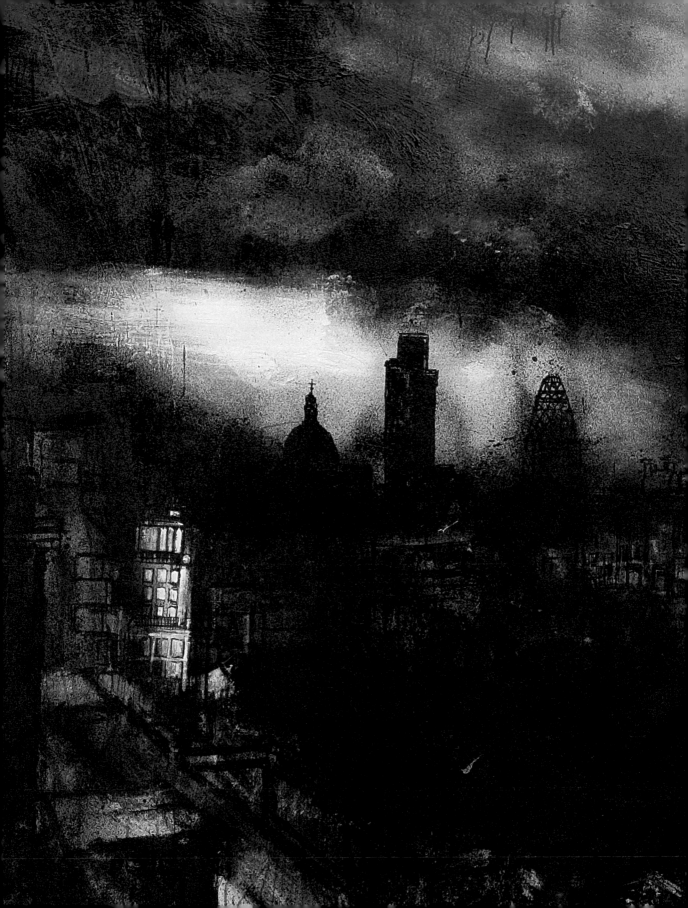

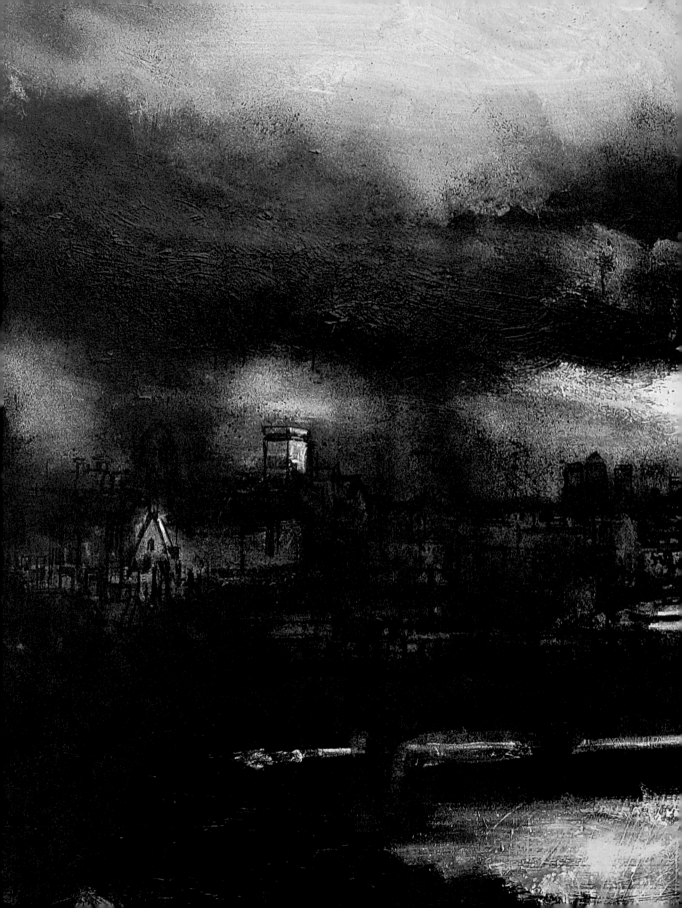

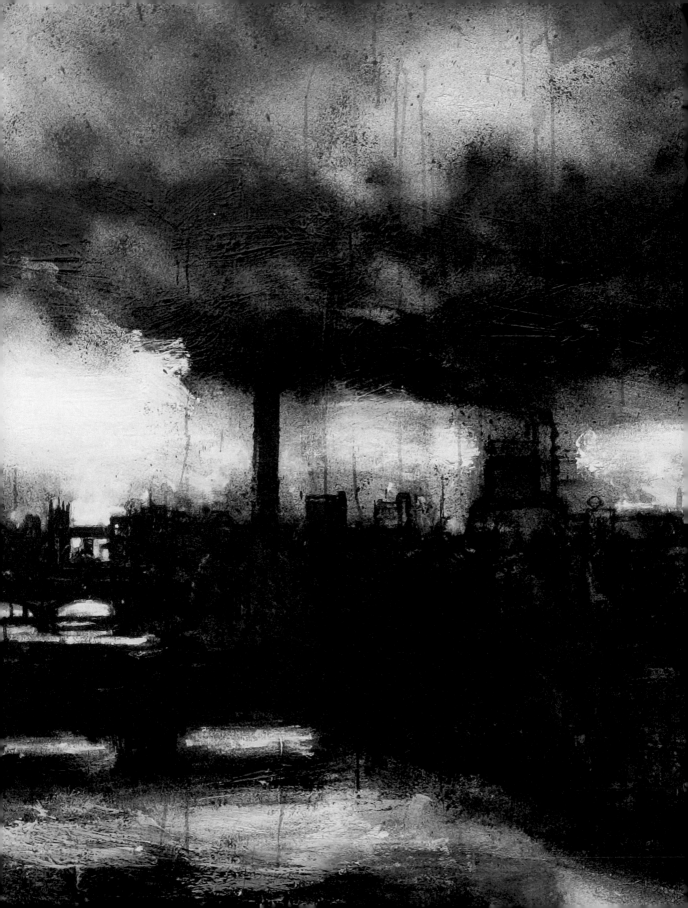

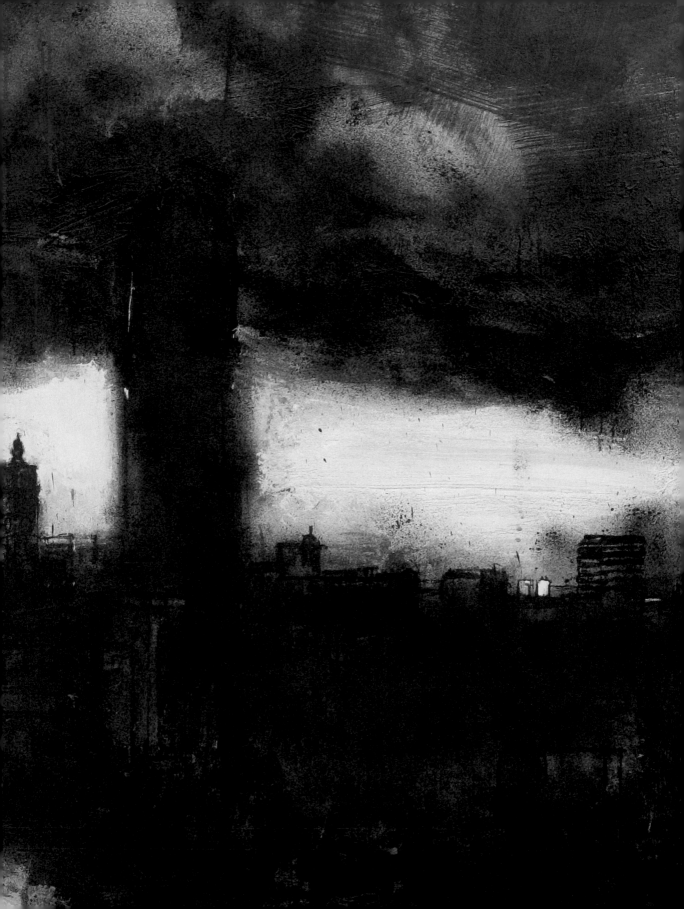

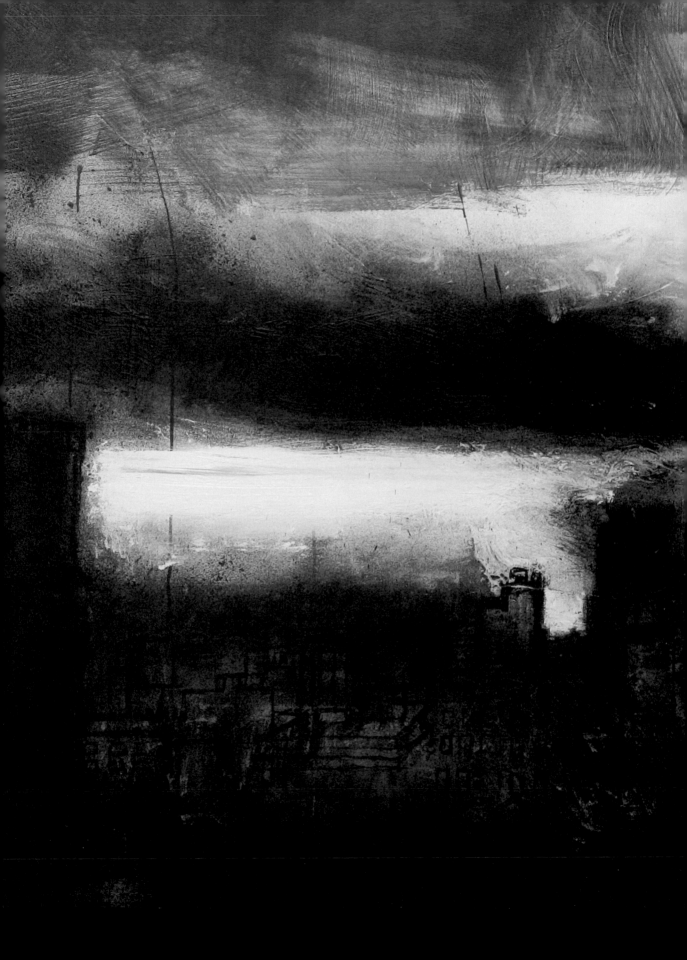

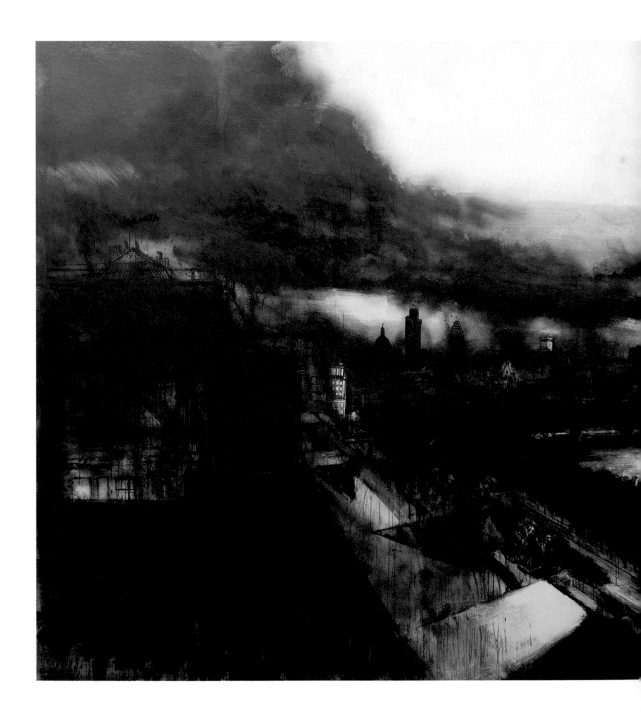

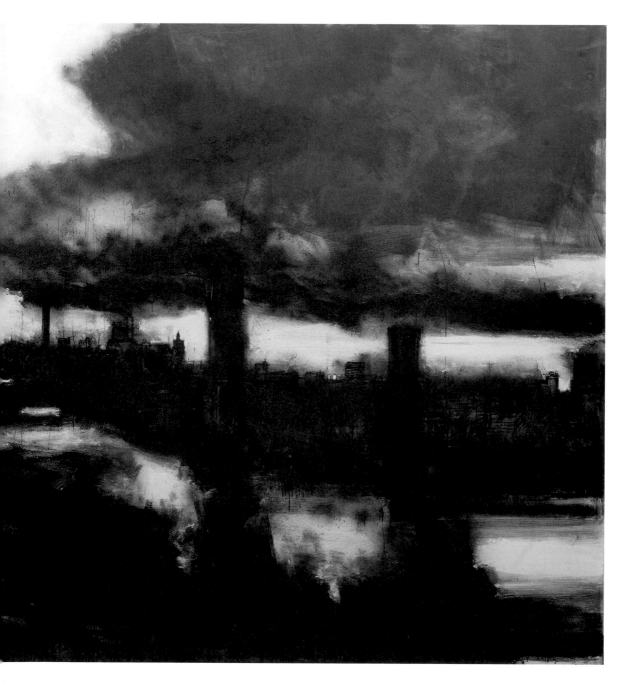

Landscape No. 710
2003–4, acrylic, black ink and shellac on canvas, 305 × 610 cm
Courtesy of the artist

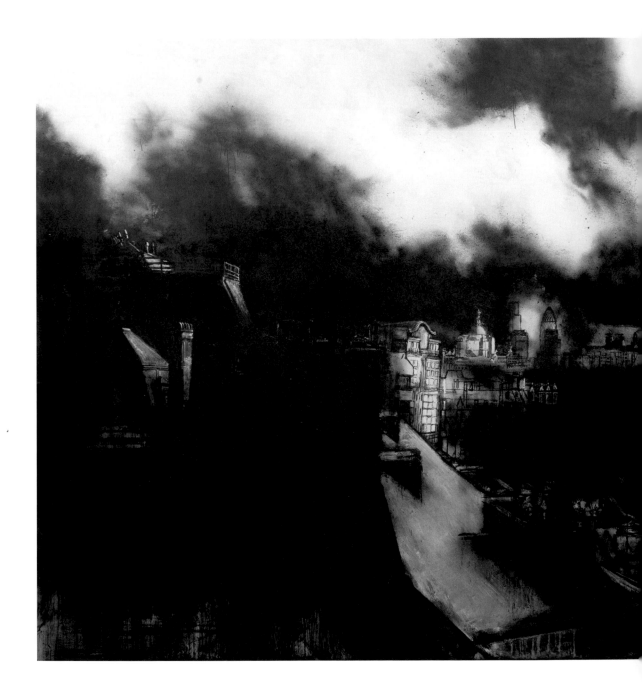

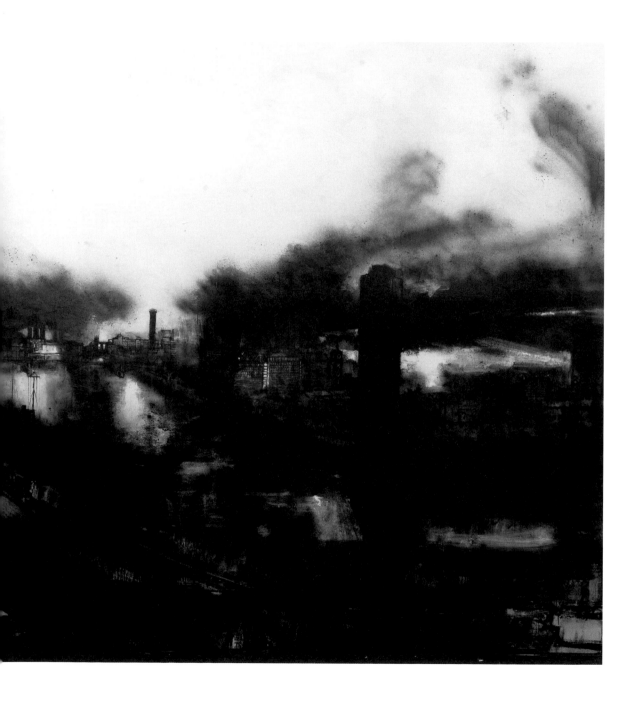

Landscape No. 711
2003–4, acrylic, black ink and shellac on canvas, 350 × 732 cm
Courtesy of the artist

JOHN VIRTUE

Biography

1947 Born Accrington, Lancashire
1965–9 Slade School of Fine Art, London
1971 Moved to Green Haworth, Lancashire
1988 Moved to South Tawton, Devon
1997 Moved to Exeter, Devon
2004 Moved to London

Solo Exhibitions

1985 *John Virtue*, Lisson Gallery, London
1986 *Works: 1985–1986*, Lisson Gallery, London*
1988 *Green Haworth 10 Years: 1978–88*, Lisson Gallery, London (travelled to Cornerhouse, Manchester and L.A. Louver, Venice, California)*
1989 *10 New Works*, Lisson Gallery, London (travelled to Louver Gallery, New York)*
1990 *Large Works and Miniatures 1989–90*, L.A. Louver Gallery, Venice, California
1991 *John Virtue,* Serpentine Gallery, London*
John Virtue, Gallery Kasahara, Osaka, Japan*
1992 *John Virtue,* Louver Gallery, New York
1993 *John Virtue,* L.A. Louver Gallery, Venice, California
The Landscapes 1991–1993, Bernard Jacobson Gallery, London*
1994 *Darklands, Terra Nera,* Galerie Buchmann, Basel, Switzerland
1995 *John Virtue: New Works,* The Douglas Hyde Gallery, Dublin (travelled to Arnolfini, Bristol; Whitechapel Art Gallery, London)*

1996 *John Virtue: Etchings,* Jason and Rhodes, London
1997 *John Virtue,* L.A. Louver Gallery, Venice, California
John Virtue: New Paintings, Jason and Rhodes, London*
1998 *Exe Estuary Paintings 1997–98*, Spacex Gallery, Exeter*
1999 *John Virtue,* Michael Hue-Williams Fine Art, London*
John Virtue: Paintings, Newlyn Art Gallery, Cornwall
2000 *John Virtue: Exe Estuary Paintings 1997–2000,* L.A. Louver Gallery, Venice, California*
2000–1 *John Virtue: New Paintings,* Tate Gallery St. Ives, Cornwall*
John Virtue, Michael Hue-Williams Fine Art, London*
2002 *John Virtue*, L.A. Louver Gallery, Venice, California
2003 *Last Paintings of the Exe Estuary*, L.A. Louver Gallery, Venice, California
Last Paintings of the Exe Estuary, Annandale Galleries, Sydney
2005 *John Virtue: London Paintings*, The National Gallery, London*
John Virtue: London Drawings, Courtauld Galleries, London*
2006 *John Virtue: London Works*, Yale Center for British Art, New Haven, Connecticut

* indicates catalogue published with exhibition

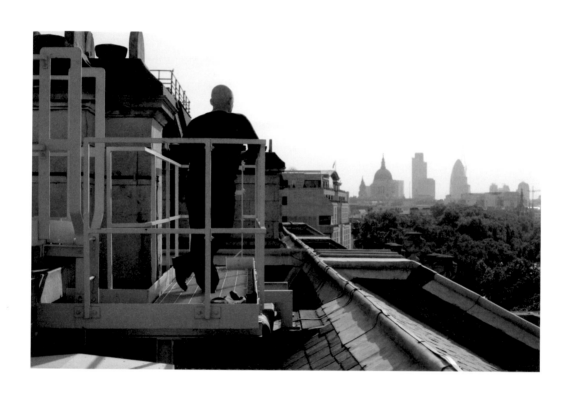

DATE DUE